Lives of

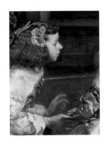

Velázquez

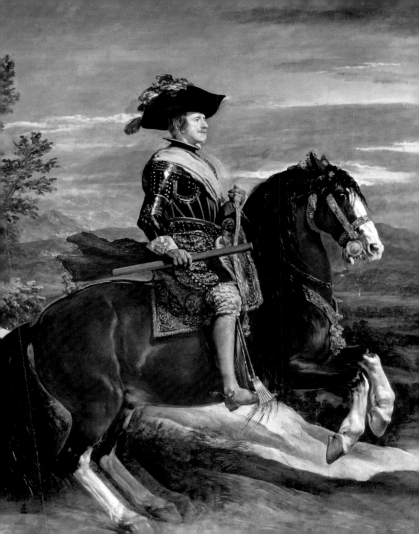

LIVES OF

VELÁZQUEZ

BY
FRANCISCO PACHECO
AND
ANTONIO PALOMINO

translated by
NINA AYALA MALLORY

with an introduction by
MICHAEL JACOBS

PALLAS ATHENE

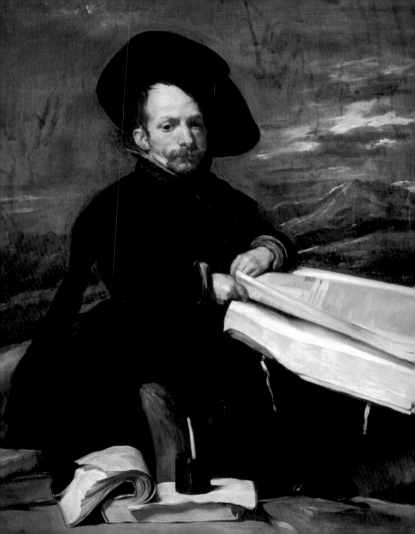

CONTENTS

Opposite: The Dwarf Diego de Acedo, 'El Primo', 1644

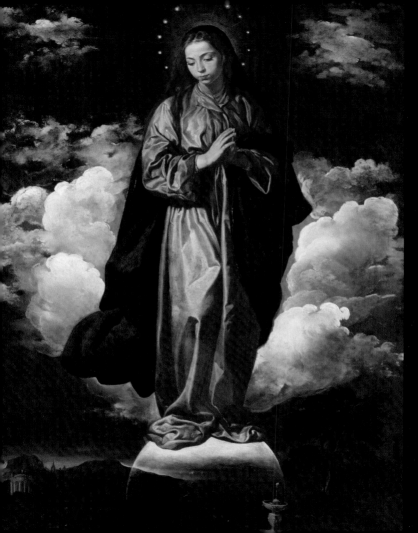

INTRODUCTION

MICHAEL JACOBS

Velázquez is an artist whose works are so dazzling in their technique and so uncannily lifelike that it is difficult at times to think of him as a man of flesh and blood. He is indeed the most elusive of mortals, as was perhaps suggested by the desperate attempt in the late 1990s to uncover the artist's corpse: all that came of this was an unsightly hole that for many months created a major traffic hazard in the very centre of Madrid. The assiduous researches of modern historians and archivists have only been marginally more successful in extending our knowledge of Velázquez the man. Despite all the documents that have recently come to light, little more has emerged about his life than can be gleaned from the two brief and highly selective biographies that are here published for the first time in a volume of their own.

The earliest of these, and the only one to have appeared during Velázquez's life time, has the advantage of having been written by someone who was not only the artist's teacher but also his father-in-law, Francisco Pacheco.

Opposite: The Immaculate Conception, c. 1618-19

Pacheco was born in 1564 in what is today the seductive and richly atmospheric Andalucían town of Sanlúcar de Barrameda, on the estuary of the Guadalquivir. Little is known about his immediate family other than that it appears to have been a comparatively humble one: two of his brothers became tailors, and another one a canvas supplier. Significantly, and in a gesture prophetic of his future son-in-law's tampering with his background, the young Francisco decided to adopt neither his father's surname of Pérez nor his mother's of del Río: instead he chose to call himself after his erudite uncle Canon Pacheco, a much respected figure in the religious and intellectual life of late sixteenth-century Seville.

Though this uncle, ironically, believed that lineage should be an insignificant factor in determining a person's merits, his nephew's decision to stress his family link with a leading Sevillian cleric seems to have been a wise career move. Moving to Seville, probably in his early teens, to become a painter's apprentice, Pacheco would have found himself in a highly competitive artistic world. Thanks to the riches coming in from the New World, the city's population had, in the course of almost fifty years, almost doubled in size to become the third largest in Europe.

Opposite: St John the Evangelist on Patmos, c. 1618-19, a pendant to the Immaculate Conception reproduced on p. 6

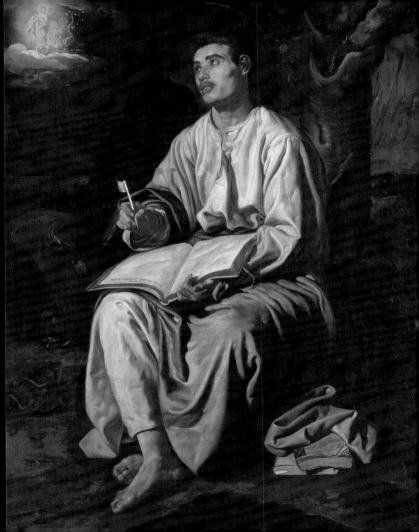

Opportunities for painting were numerous; but so too were the number of young men trying to establish a name in this field. This was a world where contacts were often more important than talent.

Pacheco, though proving at first as mediocre in his paintings as he was in his earliest literary efforts, soon gained plenty of commissions through winning the support and patronage of the city's clerical and intellectual élite. Like his learned uncle, he started attending intellectual gatherings or tertulias *in which clerics and others exchanged ideas on the arts and sciences. He was also a deeply religious man whose active involvement in church affairs would lead in 1618 to his participation in the notorious Inquisition.*

By the second decade of the seventeenth century, Pacheco was at the height of his powers, and at the head of an important studio. The stiff, Michelangelo-inspired paintings and murals for which he is best known date from his late forties onwards. This same period, coinciding with the beginnings of Seville's political and economic decline (following the first of a series of devastating plagues, and the expulsion of Spain's population of Moorish origin), saw also, paradoxically, the birth of an artistic Golden Age in which Pacheco's studio played a major role. Both Zurbarán and Alonso Cano (the 'Spanish Michelangelo') were pupils of Pacheco. But the

apprentice of whom he was most proud was Diego Velázquez, who entered the studio early in 1611, at the age of eleven, and qualified as a Master Painter six years later. In 1618 Pacheco paid the young artist the greatest compliment a teacher could pay a pupil: he gave him the hand of his daughter in marriage.

While recognizing immediately the remarkable brilliance of Velázquez, Pacheco must also have been aware of how much his pupil represented a challenge to the pedantry of his teachings. Pacheco, emulating the example of Italian artists since the Renaissance, believed that a great theoretical knowledge of art, coupled with an appreciation of the achievements of the ancient Greeks and Romans, was essential to an artist's education: accordingly he collected the many theoretical and scientific manuals on art that were available in the Seville of his day. Though Velázquez seems to have inherited a certain degree of interest in these works (the inventory at the time of his death includes a large library of such books), it is unlikely that he was an intellectual in the sense that Pacheco was. Present-day art historians, anxious to establish their own intellectual credentials, find it hard to accept the old-fashioned idea of Velázquez as an innocent eye, responsive solely to his pictorial instincts. Yet the early written sources alone strongly suggest that this was the case, and encourage us to think of him in the same way as

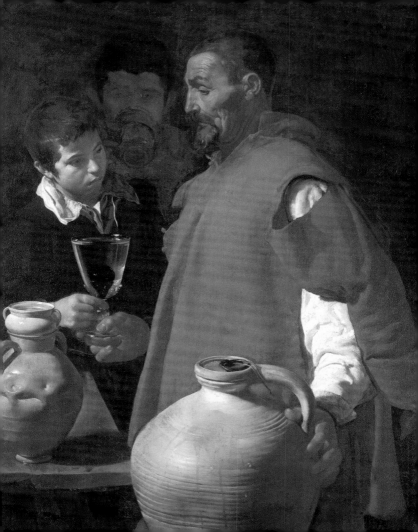

one does, for instance, the North Italian painter Mantegna, an artist clearly unhappy at having to take into account the dictates of some intellectual adviser.

The young Velázquez stressed his independent position in two significant ways: he painted directly from human models rather than from the antique; and he loved producing genre scenes, or what the Spaniards of his generation began calling bodegones *(literally tavern scenes). Perversely, in assessing the monetary value of paintings by him owned by the churchman Juan Fonseca, Velázquez put the highest price of all on* The Water Carrier of Seville *(London, Wellington Museum). To accord such importance to a type of a painting that ranked very low on the traditional classical scale of values was bound to provoke his intellectual patrons, some of whom – according to his first proper biographer Palomino – indeed reproached him for not choosing the sort of delicate, beautiful subject-matter favoured by Raphael. The artist is said to have reacted to this by saying that he preferred to be 'first in… coarseness than second in delicacy'.*

Pacheco was one of those intellectuals who did not in principle think highly of genre painting. But it is telling of his greatness as a teacher, and his loyalty to his pupil and son-in-law, that he defended Velázquez for creating

Opposite: The Water Carrier of Seville, c. 1618-22

such works. Apart from the inevitable ploy of finding justification in the example of ancient painters, Pacheco came out with the remarkably commonsensical view that bodegones *were 'worthy of esteem' as long as they were painted with someone of the incomparable skills of his pupil.*

Already in his mid-fifties by the time that Velázquez was enjoying a success greater than that of any other Spanish painter before him, Pacheco must have realized that his own most noteworthy achievement was having been a teacher to such an artist. He described his pupil as 'the greatest adornment of my later years', and took violent exception to the idea – repeated by Palomino – that Velázquez had been earlier apprenticed to the notoriously unattractive Francisco Herrera. He also strenuously denied any suggestion that he was jealous of Velázquez.

Jealous or not, he could only have been hurt to discover in 1624 that his eminent former pupil could to do little to assist him in his by now flagging career. By this date it had become obvious to most painters in Seville that the future lay now in Madrid, whose rapidly rising fortunes were in sharp contrast to the declining situation in the Andalucían capital. Pacheco, following in the footsteps of Velázquez, went off to Madrid in the hope of finding work at the court; but, like Zurbarán many years later, he failed to achieve this aim.

Frustrated as a painter, Pacheco devoted much of his last years to writing what was intended as the first general Spanish treatise on the 'Art of Painting', in which he would bring together the experiences and reflections of a life time. However, even in this aim he would be thwarted. In the midst of working on his eventual three-volume treatise, he was beaten to the post by the court artist Vicente Carducho, who, in 1633, brought out his Dialogues on Painting, *whose brief and unreliable allusions to some of Velázquez's court paintings can claim to be the first printed mentions of this artist's work. 'You cannot be sure in life even of your best friends,' commented the embittered Pacheco, who died in 1644, five years before his own* Art of Painting *was finally published.*

Pacheco's treatise, a work of scant originality, owes much to Italian renaissance writings in its plea for painters to be recognized not as craftsmen but as practitioners of a liberal art. Untranslated to this day other than as short extracts, it would be a largely forgotten work were it not for its references to Velázquez, who is featured here as one of three model artists of modern times. The other two are the Flemish painter Rubens (whom Velázquez got to know in Madrid), and the now wholly obscure Rómulo Cincinnato, a Madrid-born Italian artist who ended up in Rome. Not a single one of the latter's paintings is known today; but in any case Pacheco

appears interested in him less as an artist in his own right than as an example of the elevated social position to which artists were now able to aspire. As both a 'Knight of Christ' and an intimate to a member of the Italian nobility, Cincinnato's life might well have encouraged Velázquez's own pursuit of title and status.

It is precisely this aspect of Velázquez's life that stands out in Pacheco's extremely partial account of the man. Anyone who reads Pacheco in the expectation of a rounded portrait of his pupil is likely to be disappointed. As with Palomino's later biography, Pacheco's account of Velázquez mentions the Seville period (of which of course he would have had intimate knowledge) only in connection with the bodegones. *Instead he dwells almost entirely on his moving to Madrid, the honours and privileges bestowed upon him by Philip IV, and the triumphant first visit to Italy of 1629-31, when Velázquez appears to have been treated like some demanding film star. In Pacheco's description of the artist's lavish welcome in Ferrara by a Spanish nobleman (after having rejected a cardinal's offer of hospitality on the grounds that the latter might find his eating times peculiar), you almost imagine the author writing down in his excitement some witty, boastful tale told after dinner by his son-in-law.*

This last passage is one of those that would be copied almost word by word by Antonio Palomino in his

Spanish Parnassus of Laureate Painters, *the first published work devoted to the lives of Spanish artists. Palomino lacked Pacheco's first-hand knowledge of Velázquez; but he was in time to draw on the memories of those who did. Born in 1655 to a leading local family from the northern Andalucían town of Bujalance, he settled with his parents ten years later in the district capital of Córdoba. He received an education intended to prepare him for an ecclesiastical career, but simultaneously discovered a vocation for painting and began learning the craft while pursuing his academic studies.*

It was during this period that he made friends with a former pupil of Velázquez, Juan de Alfaro, who helped persuade him to go to Madrid, where he studied geometry at a Jesuit college. Continuing all the while to paint, he started making a name for himself above all as a fresco painter, and was even appointed court painter after executing some decorations in Madrid's soon-to-be-destroyed royal palace. However, despite this recognition, and the regular flow of commissions that followed, he is thought of today largely as the dreary last representative of the group of Madrid followers of Velázquez whose members included Claudio Coello and Francisco Rizi.

By far his best known achievement was the writing of

Overleaf: *Bacchus and his Companions ('The Topers'), c. 1628*

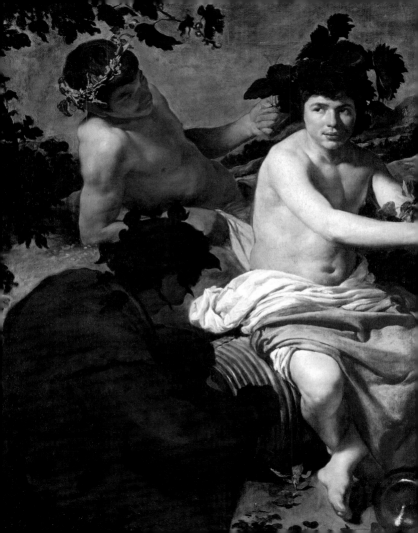

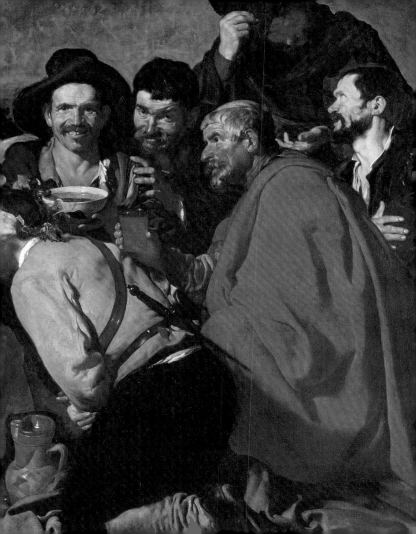

a mammoth pictorial treatise on which he was engaged for much of the latter part of his life. The Pictorial Museum and Optical Scale ('El Museo Pictórico y Escala Óptica') *was a three part work whose first section, on 'The Theory of Painting', was published in 1714. The last two parts, on 'The Practice of Painting', and on the lives of Spanish artists, came out together in 1724, shortly before the death of Palomino's wife and his subsequent decision finally to take up holy orders. He died only a few months later, in the summer of 1726, too soon to appreciate the considerable international success of his* Spanish Parnassus.

As a writer on artistic theory and practice Palomino was decidedly conventional, and largely content to reiterate what can be found in standard sixteenth and seventeenth century manuals. But he had the luck to produce his pioneering biographical section on Spanish artists at a time when foreign interest in Spain and Spanish art was beginning slowly to grow. The various eighteenth-century translations of the Spanish Parnassus *are telling of a period in which the Sevillian painter Bartolomé Murillo was coming to be ranked as one of the greatest artists of all time, and when curiosity in Velázquez was heightened by the fact that most of his works were still hidden away in the Spanish royal collections.*

The historian Agustín Ceán Bermudez, Palomino's

own first biographer, wrote in 1800 that the faults in Palomino's writings were 'due to the generosity of his character and the bad taste of his day'. Today Palomino's assessments of Spain's artists seem on the whole remarkably fair, scrupulous and objective, though inevitably marred by such prejudices of his age as the notion that Spanish art before 1500 was crude and unworthy of being written about (up to that time, he implies, the Spaniards were too busy fighting off the Moors and establishing a national identity to bother much about art). Even the works of the early 16th Flemish-born painter Pedro de Campaña – which Pacheco held up to his pupils as models of realism – suffered from never having 'lost altogether that dry Flemish manner which prevailed then'.

Palomino travelled all over Spain in search of material for his biographies, though, as he confesses in the preamble to his work, one of his main sources was a manuscript by Don Lázaro Díaz del Valle. Commissioned by Philip II as a translation of Giorgio Vasari's celebrated Lives of the Italian Artists, *and unpublished until the 20th century, this was expanded by Don Lázaro to include some Spanish artists as well. For Velázquez in particular, Palomino drew not only on Pacheco, but also on a now lost manuscript by his friend Juan de Alfaro, who seems to have been working on a biography of his former teacher at the time of his early death in 1680.*

Palomino had been present during Alfaro's last hours, but, in The Spanish Parnassus, *describes those of Velázquez with almost greater pathos, as if he had been there too. Velázquez was the true hero of Palomino's book, and is suitably the subject of its longest chapter, which is the source of most of the famous stories about the artist, from his hiring 'of a little country boy to serve him as a model', to his allowing Philip IV free access to watch him painting. The information he provides is probably more reliable than later critics would have it; and there are descriptions of paintings that could hardly be bettered. He captures the essence of Velázquez's mature style by pointing out how from close up the works are barely intelligible, but from a distance appear miraculous. And he brilliantly conveys the sense of awe inspired by* Las Meninas *by concluding that it ceases to be art to become life itself.*

Sadly, however, Palomino fails on the whole to live up to his soubriquet as the 'Spanish Vasari'. He lacks both the latter's fluency of prose, and the relish for often trivial-seeming anecdote that nonetheless brings an artist to life. Palomino, like Pacheco before him, is so reverential towards Velázquez that it is difficult to imagine what the artist really was like as a person. You long for the sort of exposé to which the great Golden Age playwright

Opposite: Las Meninas, *1656*

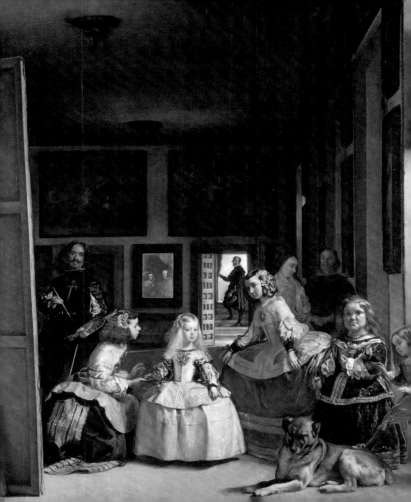

Lope de Vega was subject in the 1930s: from having been judged almost as a saint on the basis of a single contemporary biography, he was then shown by new documents to have been one of the most complex and duplicitous figures in the whole history of literature. In the case of Velázquez, the only revelation in modern times to dent slightly his worthy image has been the discovery that he had an illegitimate son in Italy.

Recent documentary research on the artist has otherwise appeared mainly to confirm an aspect of his personality that can be glimpsed in the accounts of Pacheco and Palomino, and which hardly accords with conventional notions of genius: an obsession with social status. Though known always today by his mother's surname of Velázquez, he took the greatest of pains to emphasize the supposed aristocratic lineage of his father's Portugese family, the Silvas, whom he even claimed to be descendents of Æneas's son Silvius, the mythical founder of Portugal. This aristocratic link, still regularly mentioned in the literature on the artist, was vital in making him achieve what seems at times to be his life's principal goal: to be admitted into the Order of Santiago. Yet this link was almost certainly false, for it would have been unheard of

Opposite: Don Diego de Corral y Arellano, a member of the Order of Santiago, 1631

for a nobleman to allow his son to become a painter. All the evidence suggests instead that both the artist's mother's family and the Silvas (who came from Portugal to Seville in the 1580s) were prosperous merchants.

The considerable efforts expended by Velázquez on trying to raise his social profile went hand in hand with time-consuming activities intended to supplement his income as a painter. As well as property letting in Seville (an activity which he continued after moving to Madrid), he accepted numerous court positions that had nothing to do with painting. These are listed by both Pacheco and Palomino, the former with understandable great pride, the latter with an element of regret that Velázquez should have been spent so much time distracted from his true vocation.

In trying to find out more about Velázquez's personality, clues should perhaps be sought above all in the artist's formative years in Seville. Writers on this period have devoted themselves far more to the tedious task of uncovering tenuous artistic influences (the art-historical equivalent of trainspotting) than they have to the potentially more fruitful one of relating him more generally to his native environment. For instance, in view of the constant playful contrast in his work between the real and the staged, it would be interesting to establish a connection between Velázquez and the exceptionally lively world of

Sevillian theatre. And it would be good also to know something more about his relationship with Sevillian sculptors such as Pacheco's friend Martínez Montañes ('the god of wood'), whose processional images were presumably discussed then in Seville as they are today – as if they were human beings rather than objects in polychromed wood.

From what little we know of Velázquez, he seems to have been stereotypically Sevillian in at least two important respects: he was famously witty, and an apparent sybarite. Palomino quotes two examples of the artist's quick-fire wit, while Pacheco points out how his pupil immediately recognized the advantages of spending the hot Roman summer in the shaded, hilly grounds of the Villa Medici. You are tempted to picture him relaxing in the company of someone such as Baltasar del Alcázar, a humorous Sevillian poet whose brothers Luis and Melchor did indeed look after him during his first visit to Madrid in 1621. Baltasar's famous ditty claiming that his life's three great loves were 'the fair Inés, raw ham, and aubergine with cheese' not only encapsulates Sevillian wit. It also expresses a love of life's simple pleasures that is a hallmark too of Velázquez's bodegones, *despite the*

Overleaf: An Old Woman Frying Eggs, 1618

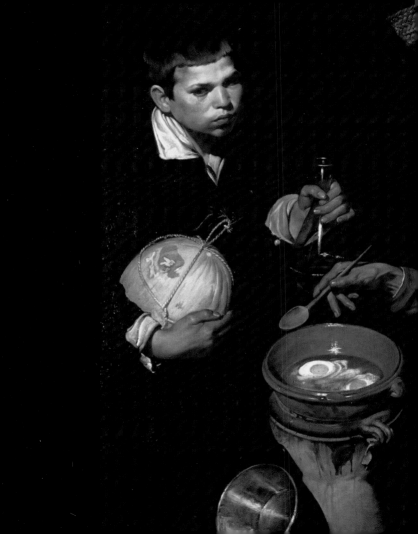

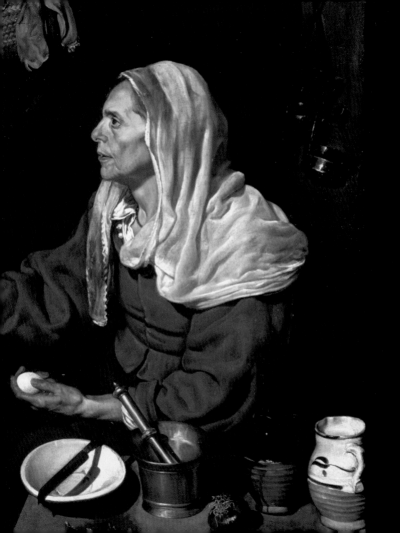

attempts of art historians to read into them deeper meanings. Thus An Old Woman Frying Eggs *(Edinburgh National Gallery) celebrates the art of frying eggs* à la puntilla, *or with a lace-like frill; and the detail of the moist jug in* The Water Carrier of Seville *is one that would have been as refreshing a sight in the Sevillian heat as a cold glass of beer is today.*

Only in Velázquez's later life does the man behind the magical technician become ever more difficult to discern. The trips to Italy, related in so much detail by Pacheco and Palomino, must have been wonderfully liberating for someone whose life after 1622 was constrained more and more by the rarefied environment of the Spanish court. Cut off increasingly in Madrid from public life, surrounded by one of Europe's most spectacular private art collections, and devising canvasses in which the real and the otherworldly are effortlessly interwoven, Velázquez must have spent much of his latter years escaping into a world which only a writer of fiction could ever attempt to record – that of his own fantasies.

FRANCISCO PACHECO

Life of Velázquez

from
Arte de la Pintura,
su antiguedad y grandezas,
descrivense los hombres eminentes
que ha avido en ella

1649

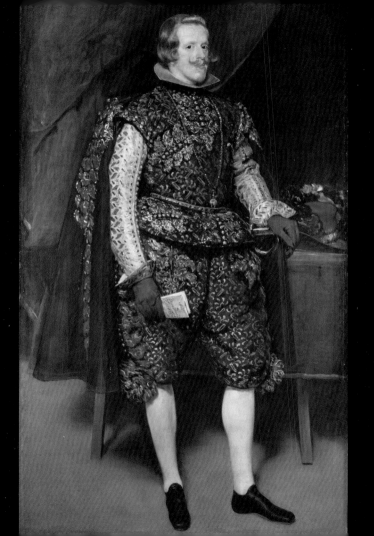

Diego Velázquez de Silva, my son-in-law, rightly occupies the third place [after Titian and Rómulo Cincinnato]. After five years of education and instruction, I gave him my daughter in marriage, persuaded to it by his virtue, chastity, and good qualities and by the expectations raised by his great native talent. And because my pride in being his master is greater than the honour of being his father-in-law, it seemed just to obstruct the audacity of someone who wishes to appropriate this glory and rob me of the crowning pride of my last years. I do not consider it a disgrace that the pupil surpasses the master, this being the truth, which is greater. Leonardo da Vinci was none the worse for having Raphael as a pupil – nor Giorgio da Castelfranco, Titian, nor Plato, Aristotle – for he did not lose his renown as Divine. I write this not so much to praise the present subject (which will be done elsewhere), as for the sake of extolling the greatness of the art of painting and, even more, out of gratitude and reverence for His Catholic Majesty, our great King Philip IV, whom Heaven keep for countless years, as it is from his liberal hands that Velázquez has received, and continues to receive, so many honours.

Opposite: Philip IV in brown and silver, c. 1623

Anxious, then, to see the Escorial, he left Seville for Madrid in the month of April of the year of 1622. He was very well treated by the two brothers, Don Luis and Don Melchior del Alcázar, and particularly by Don Juan de Fonseca, Chief Officer of His Majesty's Chapel (an admirer of his painting). At my request, he painted a portrait of Don Luis de Góngora,[1] which was much praised in Madrid, but at the time he had no opportunity to portray the King and Queen, although an attempt was made. In the same year of 1623 he was summoned by the same Don Juan (by order of the Count-Duke); he was a guest at his house, where he was fêted and served, and he painted his portrait.[2] That night, a son of the Count of Peñaranda, chamberlain of the Cardinal Infante, took it to the Palace and within the hour everyone in the Palace saw it, the Infantes and the King, which was the greatest distinction it could receive. It was decided he should portray the Infante [Carlos], but it seemed more fitting to paint the portrait of His Majesty first, although it could not be done right away due to his important engagements; in fact, it was done on August 30, 1623, to the

1. Boston, Museum of Fine Arts 2. Lost

Opposite: Luis de Góngora, 1623

satisfaction of His Majesty, the Infantes, and the Count-Duke, who asserted that the King had not been portrayed until then; and all the gentlemen who saw it felt the same.[1] While doing it, he also made a sketch of the Prince of Wales,[2] who gave him a hundred escudos.

His Excellency the Count-Duke talked to him for the first time, encouraging to do honour to his native land, and promising him that he alone would portray His Majesty, and that the other portraits would be removed. He sent him to his house in Madrid and arranged for his title on the last day of October of 1623, with twenty ducats of salary a month and payment for his works, and besides that, physician and pharmacy; another time, when he was sick, the Count-Duke sent, by order of His Majesty, the King's physician to visit him. After this, when he finished the portrait of His Majesty on horseback, done entirely from nature, even the landscape, it was set up with his consent and pleasure, in the calle Mayor in front of San Felipe, to the admiration of the entire court and the envy of fellow artists, to which I can give witness. Very handsome verses were dedicated to it, some of which will accompany this exposition. His

1. Lost 2. Lost

Majesty ordered that he be given three hundred ducats to cover his costs, and a pension of another three hundred, for which a dispensation had to be obtained from His Holiness Urban VIII in the year 1626. This was followed by the granting of a house as lodgings, which is worth 200 ducats a year.

Finally, he painted a great canvas with the portrait of King Philip III and the unexpected expulsion of the Moriscos,[1] in competition with three of the King's painters, and having surpassed them all, according to the opinion of the persons appointed by His Majesty (which were the Marquis Juan Bautista Crescenzi, of the Order of Santiago, and Fray Juan Bautista Mayno, of the Dominican Order, both great connoisseurs of painting), he rewarded him with a position of great distinction at the Palace, that of Usher to the Bedchamber, with its emoluments; and not satisfied with this, he added the stipend that is given to the Usher of the Chamber, which is twelve reales per day for his meals, and many other monies to cover his costs. And to fulfill his great desire to see Italy and the great things therein, having promised it to him several times, he

1. Destroyed by fire, 1734

Overleaf: Philip IV hunting wild boar ('La Tela Real'), 1636-8, detail

made good his royal word and, encouraging him greatly, gave him leave and four hundred ducats in silver for his trip by having him paid his salary of two years. And when he took his leave from the Count-Duke, he gave him another two hundred ducats in gold, and a medal with the portrait of the King and many letters of recommendation.

He left Madrid, by order of His Majesty, with the Marquis Spinola; he boarded ship in Barcelona on the feast-day of St. Laurence of the year 1629; he landed in Venice and lodged at the house of the Spanish Ambassador, who honoured him greatly and sat him at his table; and on account of the ongoing war, when he went out to see the city, he sent his servants with him as protection. Then, leaving that unrest behind, on his way from Venice to Rome he stopped at Ferrara, which at the time was governed, by order of the Pope, by Cardinal Sacchetti, who had been Spain's Nuncio; and gave him some letters (not giving others to another Cardinal). He received him very well, and insisted that during the days that he stayed there, he should lodge in his palace and dine with him. He excused himself modestly by saying that he did not eat at the usual hours, but if nonetheless His Eminence so wished, he would obey and change his habits. In view of this, he asked a Spanish

gentleman among those in attendance to take good care of him, and have rooms prepared for him and his servant, and be treated to the same dishes that were served at his table, and shown the city's most noteworthy sights. He stopped there for two days, and the last evening, when he went to take leave of him, he kept him seated more than three hours, conversing about different matters, and ordered the person who took care of him to get the horses ready for the next day, and accompany him for sixteen miles, down to a place called Cento, where he did not stay long but was much fêted, and bidding good-by to his guide, he followed the road to Rome, by way of Our Lady of Loreto and Bologna, where he did not stop to give letters either to Cardinal Ludovico [Ludovisi] or to Cardinal Spada, who were there.

He arrived in Rome, where he spent a year, much favored by Cardinal [Francesco] Barberini, nephew of the Pontiff, who gave orders that he be lodged in the Vatican Palace. He was given the keys to some of its rooms, the main one painted in fresco by Federico Zuccaro, above the hangings to the top, with stories from the Holy Scriptures, among them that of Moses before Pharaoh, which was engraved by Cornelius [Cort]. He left that apartment because it was far out of the way, and so as not to be so isolated, being

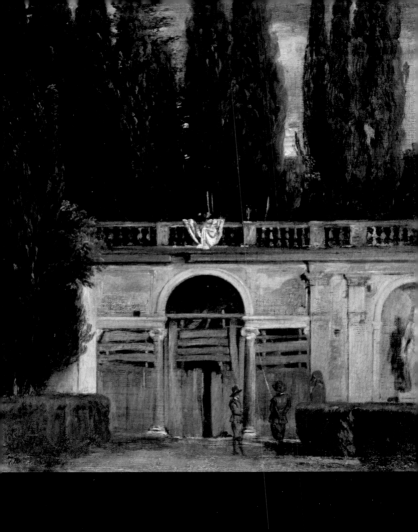

content with having the guards give him access without trouble to the *Last Judgement* of Michelangelo, or to some of Raphael's paintings when he wanted to draw from them, and he went there many days, to his great profit. Afterwards, having seen the Palace or Villa Medici, by the Trinità dei Monti, and judging it a suitable place to study and to spend the summer, since it is in the highest and coolest spot in Rome and has most excellent ancient statues to copy from, he asked the Count of Monte-Rey, the Spanish Ambassador, to negotiate with that of Florence to be given a room there, and although it became necessary to write to the Duke himself, it was arranged, and he was there for more than two months, until a tertian fever forced him to move down near the Count's house, who favoured him greatly, sending him his physician and medicines at his own expense during the days he was indisposed, and ordering that whatever he wanted was to be prepared for him at home, apart from sending many presents of sweets and inquiring about him frequently.

Among the studies he did in Rome, he did an excellent self-portrait,¹ which I own, to the admiration

1. Lost

Opposite: The Garden of the Villa Medici, 1649-50

of the connoisseurs and the glory of art. He decided
to return to Spain, where he was much needed, and
on the return trip from Rome he stopped at Naples,
where he painted a beautiful portrait of the Queen of
Hungary, to take to His Majesty.[1] He returned to
Madrid after a year and a half's absence, and arrived
at the beginning of 1631. He was very well received
by the Count-Duke, who sent him straightaway to
kiss His Majesty's hand, thanking him for not having
let any other painter portray him, and for waiting for
him to do a portrait of the Prince, which he did dili-
gently;[2] and His Majesty was very pleased by his
return. The liberality and amiability with which he is
treated by such a great Monarch is hard to credit;
having his workshop set up in his gallery and His
Majesty having a key to it, and a chair to watch him
paint at leisure, almost every day. But what surpasses
every other manner of praise is that, when he paint-
ed him on horseback, he had him seated for three
hours in a row, maintaining all the while so much
spirit and such grandeur. And the royal heart not tak-
ing into account so many favours, in seven years he
gave his father three posts as Secretary in this city,

1 Madrid, Prado 2. Boston, Museum of Fine Arts

Opposite: Infante Baltasar Carlos with a Dwarf, 1631-2

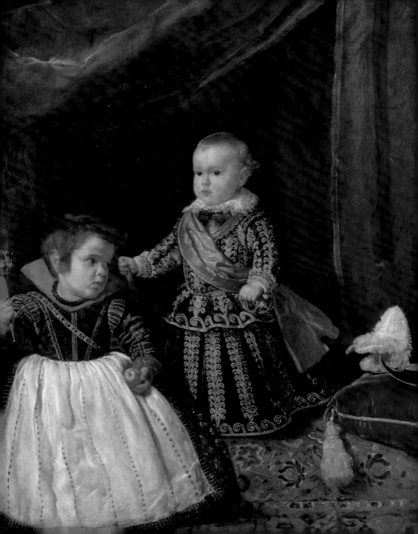

which were worth a thousand ducats each a year, and in less than two, given him the position of Gentleman of the Wardrobe, and in this year 1638 that of Gentleman of the Bedchamber, honouring him with its key, something that many Knights of the Orders would like to have. And by means of the care and diligence with which he tries to improve his service to His Majesty, we can hope for the growth and improvement in his art by someone who deserves it, as well as for the favours and rewards owed to his genius, which had he employed it on a different endeavour (without a doubt) he would not have reached the heights where he is today; and I, who share so much in his happiness, end this chapter with the following verses:

A DIEGO DE SILVA VELÁZQUEZ

Painter of our Catholic King Philip IV, having painted his portrait on horseback, his father-in-law Francisco Pacheco, being in Madrid, offered him this sonnet:

Vuela, oh joven valiente, en la aventura
de tu raro principio, la privanza
honre la posesión, no la esperanza
d'el lugar que alcanzaste en la pintura.
Anímete la augusta, alta figura

de el Monarca mayor que el orbe alcanza,
en cuyo aspecto teme la mudanza
aquel que tanta luz mirar procura.

Al calor deste sol tiempla tu vuelo
y verás cuánto estiende tu memoria
la fama, por tu ingenio y tus pinceles.
Que el planeta benigno a tanto cielo
tu nombre ilustrará con nueva gloria,
pues es más que Alexandro y tú su Apeles

OF BODEGONES

Well, then, should still-lifes not be held in high regard? Of course they should, if they are painted as

* 'Hasten, O valiant youth, to pursue the course you have embarked on with such success, so that the possession rather than the hope of the position you have attained in painting may be rewarded with royal favour./ May you be inspired by the august, eminent figure of the greatest monarch in the world, in whose appearance any change is dreaded by those who succeed in looking on such brilliance. / Temper your flight to the warmth of this sun and you will see how fame spreads your renown, thanks to your talent and your brushes./For the planet protecting that great firmament will illuminate your name with new glory, for he is greater than Alexander and you are his Apelles.'

my son-in-law paints them, surpassing in that genre every other painter without exception. And they deserve to be greatly esteemed, for with these beginnings and the portraits, about which we will talk later, he found the true imitation of nature, encouraging others by his powerful example. I myself, while I was in Madrid in the year of 1625, made an attempt once in this [genre] to please a friend, and painted for him a small canvas with two figures done from nature, flowers, fruits, and other playthings, which my learned friend Francisco de Rioja owns today, and I achieved there enough to make other things by my hand seem to have been painted with it for a model.

ANTONIO PALOMINO

Life of Velázquez

from
El Parnaso español pintoresco laureado,
being the third part of the
Museo Pictórico y escala óptica

1724

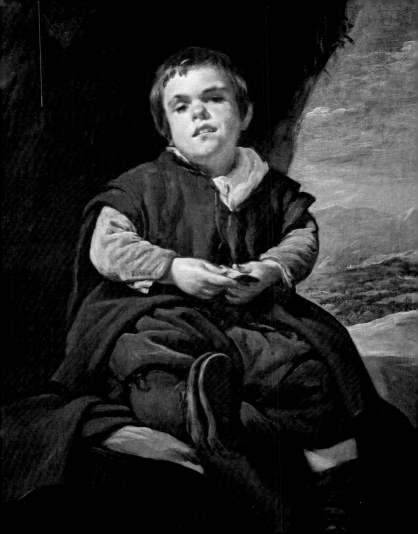

Don Diego Velázquez de Silva was born in 1594 in the illustrious city of Seville, one of the most celebrated under the sun. His parents were Juan Rodríguez de Silva and Doña Jerónima Velázquez, both endowed with the gifts of virtue, distinction, and nobility, and both natives of Seville. He chiefly used his mother's surname (a misusage introduced in some parts of Andalucía, which gives rise to great difficulties in cases of establishing proofs [of nobility]. His paternal grandparents were from the Kingdom of Portugal, members of the very noble family of Silva, which gained its renown from Silvius – posthumous son of Æneas Silvius, one of the kings of Alba Longa – from whom according to immemorial tradition, this family is descended. His ancestors served the kings of the Kingdom of Portugal and experienced the tyranny of fate: they rose to high rank, but Fortune unleashed its ire and changed their state, so they were brought down from their eminent position to endure misfortune. They were left with no other inheritance than their services and courage,

Opposite: Francisco Lezcano, 'El Niño de Vallecas', 1638-40

always regarding as their polestar the merits of their forefathers.

Nobility has its origin in the virtue of one of our ancestors, but hereditary nobility derives from maintaining that original character. Velázquez, from his earliest years, showed signs of his good nature and of the good blood that flowed through his veins, although his means were modest. His parents raised him simply and without ostentation, but with the milk of the fear of God. He applied himself to the study of the humanities and surpassed many of his contemporaries in his knowledge of languages and philosophy.

He showed a special inclination to paint, and although he displayed talent, quickness, and aptitude for all the sciences, his gifts were greater for that of painting, so that his exercise books often served him as sketchbooks for his ideas. His brilliance impressed upon his parents' hearts a very high regard for his talent, which he would develop in the course of time to such great advantage. They let him follow his bent without pursuing his other studies, since they found him already devoted to the study of painting either by natural propensity or by the dictates of fate. They handed him over for instruction to Francisco de Herrera (who is known in Andalucía as Herrera the

Elder), a harsh man of little piety but of consummate taste in painting and the other arts. After a short time, he left this school and entered that of Francisco Pacheco, a man of singular virtue, great erudition, and knowledge of painting, about which he wrote several books and composed very elegant poems, so that he was acclaimed by all the writers of his day.

Pacheco's house was a gilded cage of art, the academy and school of the greatest minds in Seville. And thus Diego Velázquez lived contentedly in the continual exercise of drawing, the prime component of painting and the main gateway to art. So Pacheco himself tells us, with his usual simplicity and candour and with a master's knowledge of the truth. 'With this doctrine (he says) was my son-in-law Diego Velázquez de Silva nurtured as a youth. He had hired a little country boy to serve him as a model for different attitudes and poses – be it crying or laughing – without shrinking from any difficulty, and he did many drawings in charcoal heightened with white on blue paper after this boy and after many other subjects from nature, so that he gained assurance in portraiture'. He liked to paint animals, birds, fish stalls, and kitchen still lifes, which he did with

Overleaf: Kitchen Scene with Christ in the house of Martha and Mary, 1618

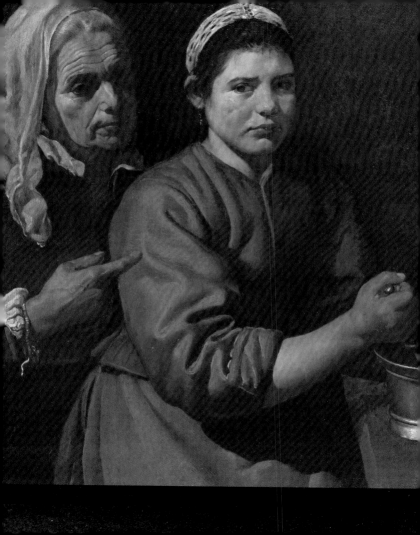

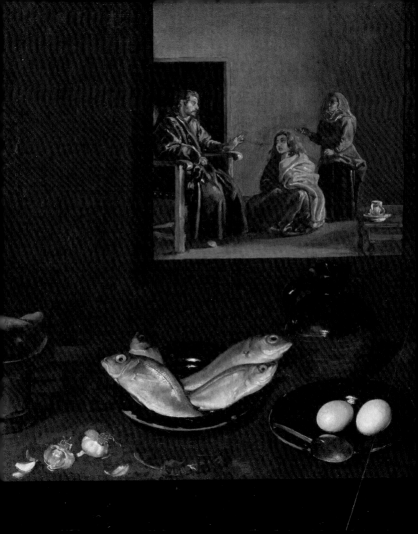

unique invention and remarkable talent, in perfect imitation of nature, with beautiful landscapes and figures, different things to eat and to drink, fruits, and poor, humble utensils, all with such mastery, good draughtsmanship, and colouring that they seem real. He took the palm in this field, leaving room for no one else, and thus earned great fame and well-deserved esteem with his works. Of these, we must not pass over in silence one that is called *The Waterseller*,[1] which shows a very poorly clad old man – with scabs and thick, rough calluses – with a ragged coat that leaves uncovered some of his chest and belly, and next to him he has a young boy to whom he gives a drink. This painting has always been so celebrated that it has been kept to the present day in the Palace of the Buen Retiro.

He made another painting of two poor men eating at a humble table on which there are various earthenware jugs, oranges, bread, and other things, everything observed with extraordinary exactness.[2] Similar to this painting is another one of a poorly dressed lad with a little cloth cap on his head, counting money at a table and keeping tally with particular care on the fingers of his left hand.[3] Behind him is a dog scruti-

1. London, Wellington Museum, ill. p. 12 2. Probably *Two Young Men at Table*, London, Wellington Museum 3. Lost

nizing some *dentones* and other fish, such as sardines, which are on the table; also on it is a Roman lettuce (the ones called 'hearts' of lettuce in Madrid) and a cauldron upside down. To the left there is a cupboard with two shelves: on one there are some large herrings and a loaf of Sevillian bread on a white cloth; on the second are two white earthenware dishes and a small clay cruet with a green glaze. He put his name on this painting, but it is very rubbed and faded by time. There is another painting similar to this one showing a board that serves as a table, with a portable stove on which a pot is boiling, covered with a small bowl; and the fire and the flames and sparks are seen vividly.[1] There is also a small tinned copper pot, a clay jug, some dishes and bowls, a glazed pitcher, a mortar and pestle, and a head of garlic next to it; on the wall can be seen a wicker basket with a cloth and other trifles. Watching over all this is a boy with a carafe in his hand and a cap on his head, which, together with his very rustic costume, makes him a very quaint and amusing figure.

This was the tenor of all that our Velázquez painted in those days in order to set himself apart from all others and follow a new course. Realizing that Titian,

1. *An Old Woman Frying Eggs*, Edinburgh, National Gallery of Scotland, ill. pp. 28-29

Dürer, Raphael, and others had already pulled ahead on a good wind and that their fame was most alive now that they were dead, he availed himself of his richness of invention and took to painting rustic subjects with great bravado and with unusual lighting and colours. Some reproached him for not painting with delicacy and beauty more serious subjects in which he might emulate Raphael of Urbino, and he replied politely by saying that he preferred 'to be first in that sort of coarseness than second in delicacy.'

Those who have been eminent and shown perfect taste in this kind of painting have become famous. It is not just Velázquez who followed such lowly inspiration; there have been many others who were led by this taste and the particular character of its idea. For instance, the celebrated painter of antiquity Piraeicus is said by Pliny to have attained the greatest glory and the highest esteem for his works by doing, humble subjects. That is why he was nicknamed *Rhyparographos*, a Greek term that means painter of lowly and coarse subjects.

From these beginnings and with his portraits, which he executed masterfully (for his eminence was such that not being content with making them extremely good likenesses, he also made them express the manner and bearing of the sitter), he

arrived at the true imitation of nature. This stimulated many others to follow his powerful example (as Pacheco tells us, for it happened to him), painting things of this kind in imitation of Velázquez.

Velázquez rivalled Caravaggio in the naturalism of his painting and equalled Pacheco in his erudition. The former he esteemed for his uniqueness and the keenness of his invention, and he chose the latter as master for the knowledge of his learning, which made him worthy of this choice. Some paintings that had been brought to Seville from Italy inspired Velázquez to try his genius at undertakings that would not be inferior to those. They were by artists who flourished in those days: Pomarancio, Cavaliere Baglione, Lanfranco, Ribera, Guido Reni, and others. The paintings that seemed most agreeable to his eyes were those of a painter from Toledo, Luis Tristán, a disciple of El Greco because he followed a path similar to his own in the singularity of his thinking and the liveliness of his ideas. For this reason he declared himself Tristán's follower and abandoned his master's manner, having realized from the very beginning that such a tepid style of painting, in spite of its erudition and good draughtmanship did not suit him, for it went against his lofty nature and taste for grandeur. Because he counterfeited nature in his

works so successfully and with such verisimilitude – always keeping it present in all he did – Velázquez was called a second Caravaggio. In his portraits he imitated Domenico Greco for, in his view, his likenesses could never be praised enough. And the truth is that this was true about everything in El Greco's work that did not partake of the bizarreness into which he fell at the end. For we can say of El Greco that 'whatever he did well, no one did better, and what he did badly, no one did worse.' Finally, Velázquez's art shone with the energy of the Greeks, the diligence of the Romans, and the tenderness of the Venetians and Spaniards, whose works were transmuted into his own, so that if their vast numbers were to be lost we could still know them from the brief compendium of his works.

He practiced the lessons to be found in the various authors who have written distinguished precepts on painting. In Albrecht Dürer he sought the proportions of the human body, anatomy in Andreas Vesalius, physiognomy in Giovanni Battista Porta, perspective in Daniele Barbaro, geometry in Euclid, arithmetic in Moya, architecture in Vitruvius and Vignola, as well as in other authors, from all of whom he skilfully selected with the diligence of a bee all that was most useful and perfect for his own use

and for the benefit of posterity. He studied the nobility of painting in Romano Alberti's treatise, written at the request of the Roman Academy and Venerable Brotherhood of the glorious Evangelist Saint Luke; he illuminated his own concepts with Federico Zuccaro's *Idea*, adorned them with the precepts of Giovanni Battista Armenini, and learned to carry them out quickly and succinctly from Michelangelo Biondo. Vasari spurred him on with his *Lives of the Most Excellent Painters*, and Raffaelo Borghini's *Riposo* made of him an erudite painter. He also perfected himself with the knowledge of sacred and secular writings and of other important things, so as to enrich his mind with every kind of learning and a general knowledge of the arts. That is what Leon Battista Alberti advises in the following words; 'Ma ben vorrei, chel Pittore fosse dotto, quanto possibil fosse in tutte le Arti Liberali; ma sopra tutto gli desidero, che sia perito nella Geometria.'* Velázquez was also well acquainted and friendly with poets and orators, for it was from such minds that he gained much with which to embellish his compositions.

And finally, Velázquez was as studious as the diffi-

* 'But I would very much want the painter to be as learned as possible in all the Liberal Arts; but above all I wish him to be expert in Geometry.'

cult nature of this art requires, persevering in it without concern for anything other than the glory and praise that is earned through knowledge and placing his trust in time and labour, which never fail to give an honourable reward to him who seeks it. He had five years of education, and in them the progress he made in his works outdistanced his age. He took a wife, choosing – to his happiness and honour – Doña Juana Pacheco, daughter of Francisco Pacheco, Regular Officer of the Holy Inquisition in Seville and member of a very distinguished family. Velázquez surpassed his father-in-law and master in the art of painting, without arousing his jealousy or envy; to the contrary, Pacheco gauged this (and rightly so) as redounding in his own honour. He admits so himself, and at the same time complains about someone who wanted to assume for himself the honour of having been Velázquez's teacher, thus robbing him of the glory of his old age (for he was more than seventy when he wrote this). Having praised Romulo Cincinnato and Peter Paul Rubens, among others, he says: 'Diego Velázquez de Silva, my son-in-law, rightly occupies the third place. After five years of education and instruction, I gave him my daughter in marriage, persuaded to it by his virtue, chastity, and good qualities and by the expectations raised by his great

native talent. And because my pride in being his master is greater than the honour of being his father-in-law, it seemed just to obstruct the audacity of someone who wishes to appropriate this glory and rob me of the crowning pride of my last years. I do not consider it a disgrace that the pupil surpasses the master, this being the truth, which is greater. Leonardo da Vinci was none the worse for having Raphael as a pupil – nor Giorgio da Castelfranco, Titian, nor Plato, Aristotle – for he did not lose his renown as Divine. I write this not so much to praise the present subject (which will be done elsewhere), as for the sake of extolling the greatness of the art of painting and, even more, out of gratitude and reverence for His Catholic Majesty, our great King Philip IV, whom Heaven keep for countless years, as it is from his liberal hands that Velázquez has received, and continues to receive, so many honours.'

II. OF THE FIRST AND SECOND JOURNEYS THAT VELÁZQUEZ MADE TO MADRID

In these exercises did Velázquez occupy the years of his youth, but Fortune did not ignore his merits, for just as the world turns, so his tranquillity was also

bound to be disturbed. Nobody is so neglected that Fortune will not remember him someday, either to overthrow his happiness or to raise his good luck to further prosperity. Who has ever died in the same condition as when he first opened his eyes to realize that he was just a fragile portion of his primordial mother, the Earth? He interrupted his studies, wishing to demonstrate the calibre of his talent at court and to improve his art by seeing the admirable paintings in the Palace and other royal seats, in churches and in noble palaces, as well as those in the Royal Monastery of San Lorenzo el Real,* eighth wonder of the world and first in greatness, a work worthy of that great monarch and second Solomon, Philip II, King of Spain.

Velázquez at last left Seville, accompanied only by a servant, setting his course toward Madrid, court of the Kings of Spain and noble theatre of the leading talents on earth. He arrived there in the month of April of 1622, and good fortune favoured him. He was visited by many noblemen, some of them moved by amiability and others by the reports of his ability and great talent; he was treated most kindly by Don Luis de Alcázar and by his brother Don Melchor, one of the choicest minds of Seville, who died in this

* i.e. El Escorial

court in 1625 at thirty-seven years of age and was mourned by the Muses with well-deserved lamentations for the loss of one of their chief laurels. He was shown particular friendship by Don Juan de Fonseca y Figueroa, Chief Officer of His Majesty's Chapel, Teacher of Divinity, and Canon of the Cathedral of Seville, an illustrious gentleman who – his keenness of intellect and great erudition notwithstanding – did not disdain the noble practice of painting and who was a great admirer of Velázquez's work.

At the request of Pacheco, his father-in-law, Velázquez made a portrait of the illustrious and excellent poet Don Luis de Góngora y Argote (Prebendary of the Cathedral of Córdoba and honourary Chaplain to His Majesty), which was highly praised by all the courtiers, even though it was painted in that style that does not equal his later manner.[1] Not having had the opportunity of portraying the King and Queen at that time – even though he sought to – he returned to his birthplace. In the year 1623 he was summoned back by the same Don Juan de Fonseca and issued a stipend of fifty ducats on the orders of Don Gaspar de Guzmán (Count of Olivares and Duke of Sanlúcar, High Chancellor, Lord Chamberlain, and favourite of King Philip IV).

1. Boston, Museum of Fine Arts; ill. p. 35

He was lodged in Fonseca's house, where he was well attended and entertained. There he painted his portrait,[1] which was taken that same evening to the Palace by a son of the Count of Peñaranda, Chamberlain of the Most Serene Cardinal Infante. Within an hour it had been seen by all the grandees, by the Infantes Don Carlos and Cardinal Don Fernando, and by the King, which was the greatest distinction it could have had. It was decided that Velázquez should portray the Infante [Carlos], but it seemed more fitting for him to paint His Majesty first. That, however, did not take place immediately, because of his many engagements. It was done, in fact, on August 30, 1623, to the satisfaction of His Majesty, of the Infantes, and of the Count-Duke, who asserted that nobody had really portrayed the King until then (although Vicencio Carducho and his brother Bartolomé Angelo Nardi, Eugenio Cajés, and José Leonardo had attempted it). All the gentlemen who saw it felt the same, among them Don Juan Hurtado de Mendoza, Duke of the Infantado and Lord Chamberlain, the Admiral of Castile and the Duke of Uceda, the Count of Saldaña, the Marquis of Castel-Rodrigo, the Marquis of El Carpio, and

1. Lost

Opposite: Philip IV, 1623

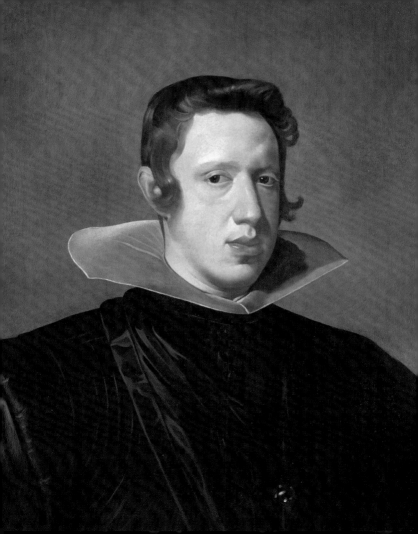

other gentlemen. The portrait showed His Majesty dressed in armour and mounted on a handsome horse – everything executed with the thought and care demanded by so great a subject – on a large canvas, life-size, and taken from nature, even the landscape.[1] He also made, while he was at it, a sketch[2] of His Most Serene Highness, Charles, Prince of Wales, titular King of Scotland, only son and heir to the kingdoms and dominions of James (King of Great Britain, Scotland, and Ireland) who was at Court at the time, lodged in the Palace. This prince, being a great lover of painting, gave Diego Velázquez one hundred escudos and honoured him with extraordinary tokens of esteem. The Prince's entry into Madrid, which took place on Friday, March 17, 1623, was recorded by Gil González Dávila, His Majesty's Chronicler.

The Count-Duke of Olivares encouraged Velázquez from the first to do honour to his native city and promised him that he alone would portray the King and that all the other portraits would be withdrawn. Thus he would enjoy the same pre-eminence as Apelles, who alone was entitled to paint Alexander's image, and as Lysippus, who could cast it in bronze, and as Pyrgoteles, who could sculpt it in

1. Lost 2. Lost

marble, an edict that the Greeks observed faithfully, as Mario Equicola d'Alvito relates in his book *De natura & amore*, Book 2, fol. 96.

He was ordered to bring his household to Madrid and given the title of Painter to the Bedchamber on the last day of October 1623, with a salary of twenty ducats per month and his works paid for, besides free doctors and medicines, and royal lodgings.

After this, when Velázquez had finished the portrait of His Majesty on horseback in such a lively pose, so gallant and spirited that it equalled Apelles – so celebrated by Greek and Roman pens – it was set up with the King's consent and for his pleasure in the Calle Mayor, in front of the Convent of San Felipe, to the admiration of the Court, the envy of his fellow artists, and the jealousy of Nature. Great poems were written on this subject, some of which are set down by Pacheco in his *Treatise on Painting* (Book 1, chapter 8), for he was in Madrid at that time, in the year 1625, as he says in page 430 of his book. But we should not leave out the famous sonnet by that illustrious talent, Don Juan Vélez de Guevara:

> *Pincel, que a lo atrevido, y a lo fuerte*
> *les robas la verdad, tan bien fingida,*
> *que la ferocidad en ti es temida,*
> *y el agrado parece que divierte.*

Di: ¿Retratas, o animas? pues de suerte
esa copia real está excedida,
que juzgara que el lienzo tiene vida,
como cupiera en lo insensible muerte.

Tanto el regio dominio, que ha heredado
el retrato publica esclarecido,
que aún el mandar la vista le ha escuchado.

Y ya que en el poder es parecido,
lo más dificultoso has imitado,
*que es más facil el ser obedecido.**

His Majesty on this occasion ordered that Don Diego Velázquez be given three hundred ducats as a gratification and a pension of a further three hundred, for which His Holiness Urban VIII had to give a dispensation. Then followed, in the year 1626, the

* 'O brush, who robs reality from daring and from strength, counterfeiting it so well that your fierceness is feared, and your grace seems to delight, / Tell me, do you portray or do you give life? / For this royal copy is so superlative that I would judge the canvas to be alive, if death were possible for inanimate things, / The portrait so clearly proclaims the royal power it has inherited that even sight has listened to its commands, / And since it is alike in power, you have imitated that which is most difficult, for it is easier to be obeyed.'

favour of royal lodgings, which are worth two hundred ducats per year.

He then painted on His Majesty's orders the canvas of the *Expulsion of the Moriscos by the pious King Philip III,*[1] the well-deserved punishment of this infamous and seditious people who, being unfaithful to God and to the King, remained stubbornly within the Mohammedan sect and had a secret understanding with the Turks and the Moors of Barbary to rebel.

Don Diego Velázquez painted this story in competition with three Painters to the King: Eugenio Cajés, Vicencio Carducho, and Angelo Nardi, and having surpassed them all in the opinion of the persons appointed by His Majesty to give it – the Reverend Father Fray Juan Bautista Mayno and Juan Bautista Crescenzi, Marquis of La Torre – it was chosen to be placed in the Great Hall, where it is still today.

In the centre of this picture is King Philip III in armour, pointing with the baton in his hand to a troop of men, women and children being led away in tears by some soldiers; in the distance are some carts and a stretch of seascape with some vessels to transport them. There are several authors who have dealt with this event and some say that there were more

1. Destroyed by fire, 1734

than eight hundred thousand Moriscos, and some that there were more than nine hundred thousand. To the right of the King is Spain, represented by a majestic matron seated at the foot of a building, holding in her right hand a shield and some arrows, and in the left some blades of wheat. She is dressed in Roman armour, and the following inscription is written on the socle at her feet:

> *Philippo III*
> *Hispan. Regi Cathol. Regum Pientissimo*
> *Belgico, Germ afric. Pacis, & Iustitiæ*
> *Cultori; publicæ Quietis assertori; ob*
> *eliminatus fœliciter Mauros,*
> *Philipus IV robore ac virtute*
> *magnus, in magnis maximus,*
> *animo ad maiora nato, propter*
> *antiq. tanti Parentis, &*
> *Pietatis, observatiæ*
> *que, ergo Trophæum*
> *Hoc erigit anno 1627.**

Velázquez finished it that year, as is attested to by the signature that he placed on a piece of simulated

* 'To Philip III, Catholic King of Spain; most pious King of

parchment that he painted on the bottom step, which says thus:

> *Didacus Velázquez Hispalensis.*
> *Philip. IV Regis Hispan.*
> *Pictor ipsiusque iusu, fecit,*
> *anno 1627.†*

In that year His Majesty honoured Velázquez with the position and wages of Usher to the Bedchamber – a very noble office, as is made clear in the books of Court records of the Royal Council of the Household. And in the year 1628, since His Majesty considered himself well served and was pleased by Velázquez's endowments, he awarded him the Bedchamber allowance of twelve reales per day, and a dress allowance of ninety ducats per year.

That same year, Peter Paul Rubens (miracle of genius, talent, and fortune, as various authors tell us

Belgium, Germany and Africa, fosterer of peace and justice, preserver of the public order ; in recognition of his succesful expulsion of the Moors, Philip IV, great in strength and virtue, greatest among the great, with a spirit born for the greatest things by reason of the antiquity of his important lineage, and moved by reverence, erected this monument in the year 1627.'

† 'Diego Velázquez of Seville, Painter to Philip IV, King of Spain, by whose command he made this in the year 1627.'

Christian after the Flagellation contemplated by the Christian Soul, c. 1628

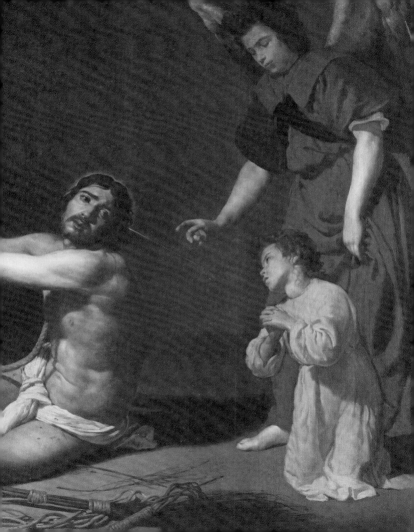

and his works proclaim) came to Spain as Ambassador Extraordinary of the King of England in order to arrange the peace with Spain. This was commanded by Archduke Albert and the Most Serene Doña Isabel Clara Eugenia, his wife, on account of the great esteem in which they held Rubens and of the fame of his erudition and talent, of which we spoke in his *Life*.

As Pacheco says, [Rubens] had little contact with painters; only with Don Diego Velázquez (with whom he had previously corresponded) did he strike a very close friendship (because of his great talent and modesty), and he looked upon his works with favour. Together they went to El Escorial to see the famous Monastery of San Lorenzo el Real, and both took a special delight in seeing and admiring so many and such admirable marvels in that sublime structure, especially the original paintings by the greatest artists that have flourished in Europe. Their example served Velázquez as a new stimulus to arouse the desire he had always had to go to Italy to look, think, and study from those splendid paintings and sculptures that are a shining torch for art and the worthy objects of our admiration.

III. OF THE FIRST JOURNEY TO ITALY MADE BY
VELÁZQUEZ BY PERMISSION OF HIS MAJESTY

To fulfill Don Diego Velázquez's great desire to see Italy and the great things therein, His Majesty, who had promised it several times, made good his royal word and gave him leave and great encouragement to go and four hundred silver ducats for his journey, having him paid for two years' salary. When Velázquez took his leave from the Count-Duke, the latter gave him another two hundred ducats in gold, a medal with the King's portrait, and many letters of recommendation. He left Madrid with Don Ambrogio Spinola, Marquis of Los Balbases and Captain-General of the Catholic armies in Flanders, and embarked at the port of Barcelona in the month of August (the most propitious time for sailing) of 1629 on the feast day of Saint Laurence. He landed in Venice (famous city founded on the Adriatic), where he saw and admired the greatness and unique-ness of the place and the various nations that trade there. He lodged in the house of the Spanish Ambassador, who honoured him greatly and seated him at his table; and when Velázquez went to look at the city, the Ambassador would send his servants with him to protect his person, on account of the

wars being waged at the time. He was taken to the church of Saint Mark's and to the Palace, splendid in size, design and majesty, with all its rooms adorned with paintings by Jacopo Tintoretto, Paolo Veronese, and other great artists. But the one that provoked the greatest admiration in him was the Sala del Gran Consiglio, which is said to hold twelve thousand persons, and just the sight of it arouses awe and admiration. In it is that celebrated picture of *Paradise* that Jacopo Tintoretto, most excellent painter (superior to all others, like another Zeuxis of antiquity), painted with such harmony in the angelic choirs and such diversity of figures (Apostles, Evangelists, Patriarchs, and Prophets) in the most varied attitudes that the hand seems to have equalled the idea.[1] The ceiling and the walls are painted with stories and portraits of the Doges of that Republic, to do which Tintoretto was retained at a salary of six hundred ducats. He also saw the *Wars of Chiaradadda*, a province that borders on the Empire, painted by Titian's hand in a large hall.[2]

He saw as well the Scuola di San Luca, or Academia, where the painters get together and from where so many famous ones have emerged to do credit to their native city as the school of colour.

1. In situ 2. *The Battle of Cadore*, in fact destroyed in 1527

Such were the great Titian, Veronese, Tintoretto, Antonio Licino da Pordenone, Jacopo Bassano and his son Bassanino, Fra Sebastiano del Piombo, Giovanni Bellini (Titian's master) and his brother Gentile Bellini, Giovanni Battista Timoteo, Jacopo Palma and his grandson Jacopo Palmeta, Giorgione, Andrea Schiavone, the sculptor Jacopo Sansovino, Simone Peterzano (Titian's disciple), and many others by whom there are famous works and whose portraits ennoble and adorn the Academia.

During the days that he spent there, he drew a great deal, particularly after Tintoretto's painting of the *Crucifixion of Christ Our Lord*,[1] a work abundant in figures and of admirable invention of which there is a print in circulation. He made a copy of a painting by the same Tintoretto, of *Christ administering the Eucharist to his disciples*,[2] which he brought to Spain and presented to His Majesty.

He became very fond of Venice, but on account of the great unrest caused by the wars being waged then, he sought to leave it to go on to Rome. He went to Ferrara, which at the time was governed – by order of the Pope – by Cardinal Giulio Sacchetti, a Florentine and Bishop of Frascati, who had been Nuncio in Spain. Velázquez went to give him some

1. Scuola di San Rocco 2. This copy is lost

letters and kiss his hand, and the Cardinal received him very well and insisted especially that during the days that he spent there he should stay in his palace and eat with him. Velázquez modestly excused himself on the grounds that he did not eat at the ordinary hours, but if His Eminence so desired, he would obey nonetheless and change his habits. In view of this, Cardinal Sacchetti instructed a Spanish nobleman among those who served him to take great care in waiting on him and have rooms prepared for him and for his servant, to treat him to the same dishes that were prepared for his own table, and to have him shown the most noteworthy things in the city. He was there for two days, and although he was just passing through, he looked attentively at the works of Garofalo. The last evening, when he went to take his leave from His Eminence, he was detained by him for more than three hours, sitting and discussing different matters. Cardinal Sacchetti ordered the person who looked after Velázquez to get the horses ready for the following day and to accompany him for sixteen miles down to a place called Cento. There he spent a short but very agreeable time, and then, letting his guide go, he continued on his way to Rome, passing through Our Lady of Loreto and Bologna, where he did not stop even to present letters to

Cardinal Niccolò Ludovisi of Bologna, Grand Penitentiary and Bishop of Policastre, or to Cardinal Baldassarre Spada, Patriarch of Constantinople and Bishop of Sabina, who were there, so as not to mortify his impatient desires.

He arrived at last in the city of Rome, where he spent a year, much favoured by Cardinal Francesco Barberini (nephew of Pope Urban VIII), by whose order he was lodged in the Vatican Palace. He was given the keys to some rooms, the most important of which was painted in fresco by the hand of Federico Zuccaro with stories from Holy Scripture, from the hangings up to the very top of the walls.[1] He left that apartment because it was too distant and so as not to be so isolated, being content with having the guards let him through whenever he wished to draw from Raphael's works and from the *Last Judgement* that Michelangelo Buonarroti painted in fresco in the Papal Chapel by order of Pope Julius II, a work on which he spent eight years and which he unveiled in 1541.[2]

Velázquez spent many days there, to the great profit of his art, making different drawings – some in colour, some in pencil – of the *Judgement*, the *Prophets*

1. Now part of the Museo Gregoriano Etrusco 2. The Sistine Chapel altar wall

81

and the *Sibyls*,[1] the *Martyrdom of Saint Peter*, and the *Conversion of Saint Paul*,[2] all of them marvellous works, executed with profound understanding. He also drew from the excellent paintings by Raphael Sanzio of Urbino in the Papal Apartments:[3] from a large picture in which Theology is joined to Philosophy, with the Sacred Host in the centre of an altar and the Doctors around it, and behind them other saints who discuss this mystery, everything done with singular decorum and admirable disposition.[4] He also drew from another scene that shows *Saint Paul in Athens preaching to the Philosophers*[5] and, closer still, from another famous painting of the celebrated *Mount Parnassus*, with the Muses and the poets, and Apollo playing a lyre in the centre.[6]

Later, having seen the Palace, or Vigna, of the Medici at the Trinità dei Monti, Monastery of the Order of the Minims, and since it seemed to him a suitable and convenient place in which to study and spend the summer because it is in the highest and airiest part of Rome and because there are most excellent antique statues there to copy he asked Don Manuel de Zuñiga y Fonseca, Count of Monte-Rey

1. The Sistine chapel ceiling 2. These last two are in fact in the Capella Paolina. 3. Now known as Raphael's Stanze. 4. The *Disputà* 5. In fact one of the tapestries for the Sistine chapel 6. In situ

(who was in Rome at the time as Ambassador of His Catholic Majesty) to negotiate with the Florentine Ambassador for him to be given rooms there. Although it was necessary to write to the Grand Duke, this was expedited by the protection of the Count, who esteemed Velázquez highly both for his endowments and for the way His Majesty honoured him. He spent over two months there, until a tertian fever forced him to move down near the house of the Count, who showed Velázquez great favour during the days that he was indisposed, sending his doctor and medicines at his own expense and ordering that anything he wanted should be prepared for him at home (apart from the many presents of sweets and frequent provisions sent by him) until he was cured of his illness and continued his studies of the outstanding paintings and sculptures that can be admired in that great metropolis of the world.

Don Diego Velázquez painted during that time the famous picture of Joseph's brothers when – envious of the good fortune to which he was predestined and after other outrages – they sold him to some Israelite merchants and brought back to their father Jacob his tunic stained with the blood of a lamb, so

Overleaf: The Forge of Vulcan, 1630

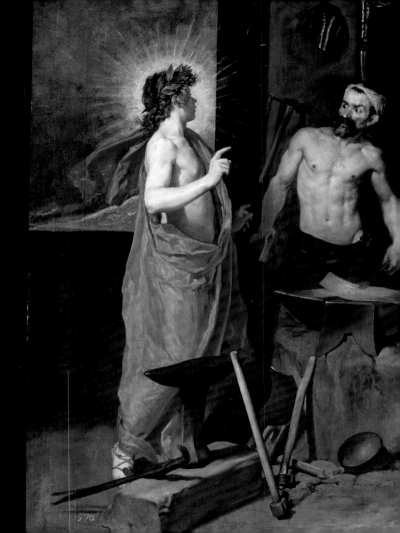

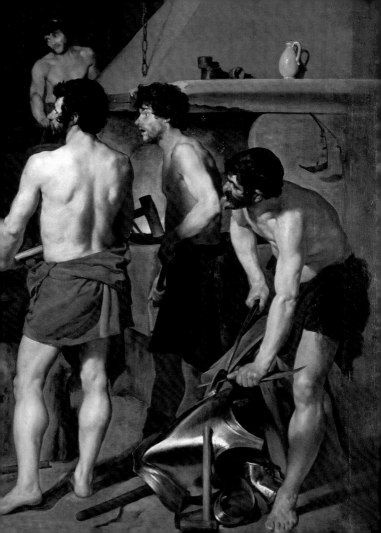

that he, filled with sorrow, believed that some wild beast had torn him to pieces.[1] This is conveyed by means of such superlative expressions that it seems to compete with the reality of the event itself. This is no less true of another picture he painted during the same period, the fable of Vulcan, when Apollo gave him the news of his misfortune – the adultery of Venus with Mars – and where Vulcan, assisted at his forge by the gigantic Cyclops, appears so pale and troubled that he seems to have lost his breath.[2] Velázquez brought those two paintings to Spain and presented them to His Majesty, who showed for them the esteem that they deserved by having them hung in the Buen Retiro, but the one of Joseph was later moved to El Escorial and is in the Chapter Hall.

Velázquez decided to return to Spain because he was much needed in the King's service, and on his way back from Rome he stopped in Naples. There he painted a beautiful portrait of Doña Maria of Austria, Queen of Hungary,[3] who was born in Valladolid on August 18, 1606, and in 1631 married the Most Serene Ferdinand III, King of Bohemia and Hungary (her cousin and son of Emperor Ferdinand II), who was elected by a most felicitous

1. El Escorial 2. Madrid, Prado 3. Madrid, Prado

choice King of Rome on December 22, 1636. Velázquez returned to Madrid after a year and a half's absence, arriving at the beginning of 1631. He was very well received by the Count-Duke, who sent him straightaway to kiss His Majesty's hand and thank him for not having allowed any other painter to portray him and for waiting for him to portray the Most Serene Prince Baltasar Carlos (which he promptly did[1]); and His Majesty showed great pleasure at his arrival.

The liberality and amiability with which such a great monarch received our Velázquez is hard to credit. He ordered him to set up his workshop in the Royal Palace in the gallery that is called 'of the North Wind,' to which His Majesty had the key and where he had a chair to watch him paint at leisure, just as Alexander the Great had done with Apelles, whom he went to watch paint in his workshop very regularly, honouring him with such singular favours as Pliny relates in his *Natural History*, and as His Imperial Majesty, Emperor Charles V, even though occupied with so many wars, liked to go to watch the great Titian paint, and as the Catholic King, Philip II, went very frequently to watch Alonso

1. Boston, Museum of Fine Arts, ill. p. 45

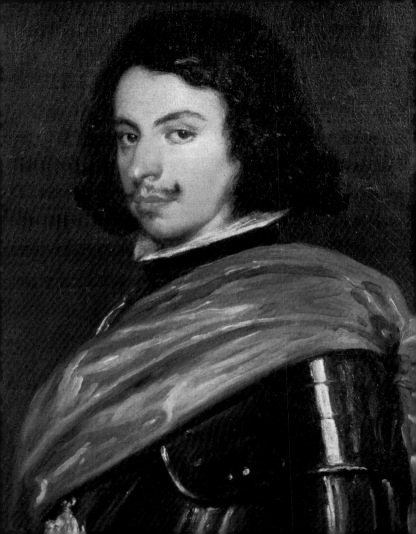

Sánchez Coello paint, favouring him with singular demonstrations of affection. Thus did His Majesty honour Velázquez (imitating and even surpassing his heroic predecessors) with the position of Gentleman of the Wardrobe, one of the most highly, esteemed offices or appointments in the Royal Household. He honoured him as well with the key to his bedchamber, something that many Knights of the Orders would like. And continuing on his advancement, Velázquez came to hold the post of Gentleman of the Bedchamber although he could not exercise it until the year 1643.

First among the most notable portraits painted by Don Diego Velázquez at this time must be that of Francesco, Duke of Modena and of Reggio,[1] done while he was in this Court of Madrid in the year 1638, when he was godfather to the Most Serene Infanta Doña Maria Teresa (together with Madame Marie de Bourbon, Princess of Carignan, to whom His Majesty Philip IV, her uncle, gave singular demonstrations of esteem). The Duke honoured Velázquez greatly, praising his rare genius, and since he had portrayed him much to his liking, he rewarded

1. Galleria Estense, Modena

Opposite: Francesco d'Este, Duke of Modena, 1638

him most liberally, especially with a precious gold chain that Velázquez sometimes would wear around his neck, as was the custom on festive occasions at the Palace.

Around this time, Velázquez also made a celebrated picture of the *Dead Christ on the Cross*,[1] life-size, which is in the cloistered part of the Convent of San Plácido in this Court – although there is another one in the Buena Dicha (a very exact copy) on the first altar on the right as one enters the church – and both have two nails through the feet on the suppedaneum, in accordance with his father-in-law's opinion concerning the four nails.

In the year 1639, he painted the portrait of Don Adrián Pulido Pareja, native of Madrid, Knight of the Order of Santiago, Captain-General of the Navy and Fleet of New Spain, who was here at the time with several petitions related to his service with His Majesty. This portrait is from life and is one of the most celebrated ones painted by Velázquez, and as such he put his name on it, a thing he rarely did. He painted it with regular brushes and with thick brushes with long handles that he owned and that he used sometimes in order to paint from a greater distance

1. Madrid, Prado

Opposite: Christ on the Cross, c. 1638

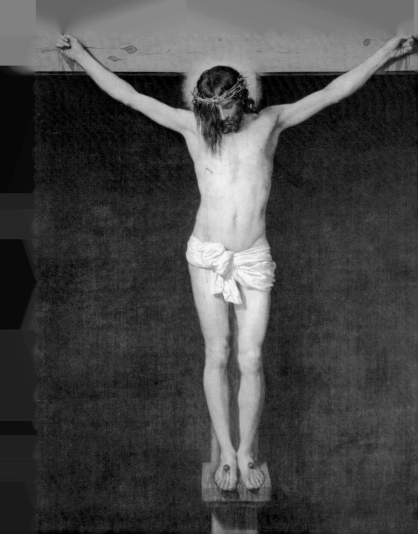

and more boldly, so that from up close the painting was not intelligible, but from a distance it was a miracle. The signature is like this:

Didacus Velázquez fecit
Philip. IV
a cubiculo, eiusque Pictor,
anno 1639. *

It is said that after this portrait was finished, Velázquez was painting in the Palace with it placed where there was little light when the King came down to watch Velázquez paint – as was his custom – and noticing the portrait and judging it to be the person itself, said with surprise, 'What? Are you still here? Have I not already dismissed you? How is it you are not leaving?' Until, surprised that he neither made the proper obeisance nor replied, His Majesty realized it was the portrait and turned to Velázquez (who modestly pretended not to notice), saying, 'I assure you that I was deluded.' This rare portrait is owned today by His Excellency the Duke of Arcos.[1]

*'Diego Velázquez, Painter to the Bedchamber of Philip IV, executed this in the year 1639'.

1. London, National Gallery; now attributed to Martínez del Mazo, Velázquez's son-in-law

IV. HOW VELÁZQUEZ SERVED HIS MAJESTY ON HIS JOURNEY TO THE KINGDOM OF ARAGÓN

In the year 1642 Velázquez attended upon His Majesty on the journey that he made to the Kingdom of Aragón with the sole purpose of bringing peace to the Principality of Catalonia, and he returned to this Court on Saturday, December 6.

In the year 1643, His Majesty commanded Don Gaspar de Guzmán, Count-Duke of Olivares, to retire to live in the city of Toro, which he was not to leave without his express permission and where he died on July 22 of the year 1645. From there he was transferred, going through this Court, to the Convent of Discalced Carmelites in the town of Loeches. Diego Velázquez could not help regretting this, having been Olivares's creature and owing him some special honours, but His Majesty continued to honour him as until then. Thus, in the year 1644, he ordered Velázquez to serve him during the journey that His Majesty made again to Aragón so as to give by his proximity strength and courage to his soldiers in the war with Catalonia. Velázquez was in Zaragoza, where His Majesty stopped, and in Fraga. The city of Lérida, which had been overpowered by the French armies, surrendered at the appearance of its King

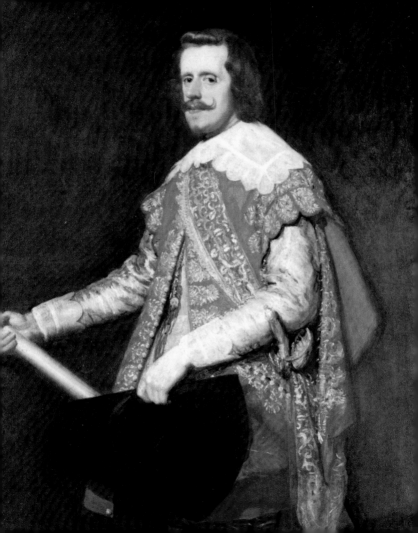

and natural lord on Sunday, the 31st of July of that year, and His Majesty entered it to sovereign applause on Sunday, the 7th of August. Diego Velázquez painted a spirited life-size portrait of His Majesty to send to Madrid, showing him as he entered Lérida, wielding the military baton and dressed in crimson plush, with such a fine air, so much grace, and such majesty that it seemed another living Philip, so one could truly say about it what was said about the portrait of Alexander by Apelles (who had painted him with a thunderbolt in his hand on account of his speed in charging against his enemies and in whipping his soldiers into shape). This figure represented the original in such a lifelike fashion that the Macedonians used to say that, of the two Alexanders, the one begotten by Philip could not be vanquished, and the one painted by Apelles could not be imitated.[1]

Diego Velázquez also painted two portraits, one of His Catholic Majesty, the King our lord Philip IV, and the other of his brother, the Most Serene Cardinal Infante Don Fernando of Austria, from life, standing dressed in their hunting clothes with their guns in their hands and their dogs held by the leash,[2]

1. New York, Frick Collection 2. Both Madrid, Prado

Opposite: Philip IV at Fraga, 1644

at rest. It seems as if he had seen them return at the hottest hour of the day, tired from the arduous but delightful exercise of the hunt, in graceful disarray, their hair dusty (not as is worn by the courtiers today) and their faces bathed in sweat, just as Martial describes Domitian on a similar occasion, handsome with sweat and dust:

> *Hic stetit Arctoi formosus pulvere belli,*
> *Purpureum fundens Caesar ad ore iubar.* *

And Diego Velázquez could have imitated many other poets who explain how much charm is added to beauty by fatigue, insouciance, and disarray. These two paintings are in the Torre de la Parada, a delightful seat for the recreation of Their Majesties.

Velázquez also portrayed admirably the most eminent and Catholic lady Doña Isabel of Bourbon, Queen of Spain, richly attired and mounted on a beautiful white horse, whose colour could have earned him the name of swan. It is a horse that has royal grandeur and appears to be light and steady,

*'Here, graced by the dust of Northern war, stood Cæsar, shedding from his face effulgent light.' (trans. Ker)

Opposite: The Cardinal Infante Don Fernando hunting, c. 1638

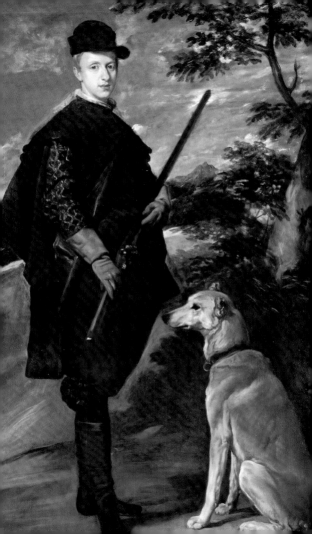

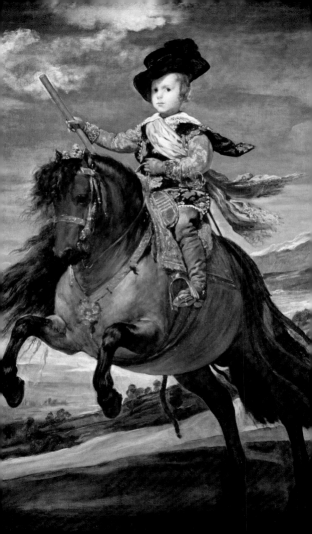

and although it is clear that he was chosen among many as being the sprucest, most elegant, tamest, and most reliable, it is not so much for this that he looks so proud as because the gold that softly bridles him seems a reverent bit, for it venerates a heavenly contact in the reins touched by a hand worthy of holding the sceptre of such a great Empire.[1] The portrait is life-size and hangs in the Salón Dorado of the Buen Retiro together with that of the King our lord on horseback that we have already mentioned, one at either side of the principal door.[2] Above this painting is another picture with the portrait of the Most Serene Prince Don Baltasar Carlos, who, although young in years, is shown in armour and riding a pony, with a generalissimo's baton in his hand.[3] The pony, running with great impetus and speed, seems to be seeking the battle with impatient pride, breathing fire, his master's victory already foreseen.

He painted another picture of elaborate composition that portrays this Prince being taught how to ride a horse by Don Gaspar de Guzmán, Count-Duke of Sanlúcar, his Master of the Horse. This

1. Madrid, Prado; finished by another hand 2. In fact another equestrian portrait of Philip IV, c. 1634-5, now in the Prado, illustrated p. 2 3. Madrid, Prado.

Opposite: The Infante Don Baltasar Carlos on horseback, c. 1634-5

painting is owned today by the house of the Marquis of Heliche, his nephew, where it is highly valued and esteemed.[1]

Don Diego Velázquez painted another portrait of his great protector and Maecenas, Don Gaspar de Guzmán, third Count of Olivares, mounted on a fiery Andalucían horse that had drunk from the Betis not only the swiftness of the course of its waters, but also the majesty of their flow, covering in silver the gold of the bridle with the froth of his mouth, a thing that the ancient and eminent Protogenes found difficult to imitate.[2] The Count is dressed in armour inlaid in gold; he wears a hat with splendid plumes, and in his hand is a general's baton. He seems to sweat from the weight of his armour and the labours of combat as he races during the battle. Farther back can be descried the troops of both armies, where one can admire the fury of the horses and the fearlessness of the combatants; and it seems that one can see the dust, look at the smoke, hear the clangour, and fear the carnage. This portrait is life-size and one of the largest paintings done by Velázquez. A panegyric in its praise was written by Don García de Salcedo

1. Possibly a painting now in the Grosvenor Collection 2. Madrid, Prado.

Opposite: The Conde-Duque Olivares on horseback, c. 1635

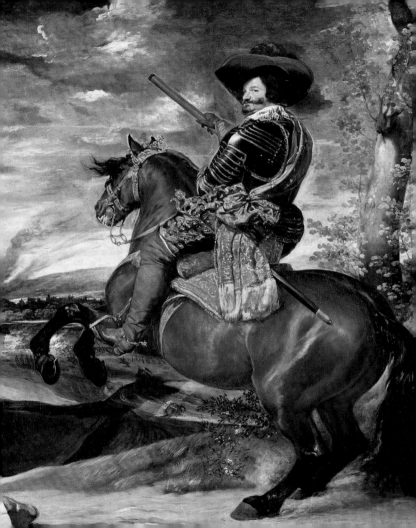

Coronel, Equerry of the Most Serene Cardinal Infante, a man of such outstanding talent and such a superior mind that he can with very good reason say with Ovid:

Mortale est, quod quaeris opus: mihi fama perennis
*Quaeritur, ut toto semper in orbe cannar.**

Velázquez made another portrait of Don Francisco de Quevedo Villegas, Knight of the Order of Santiago and Lord of the town of Torre de Juan Abad. His printed works bear witness to his rare talent, for he was a divine Martial of Spanish poetry and a second Lucian of prose; only Lucretius's words when he sings of Ennius can be said in his praise:

Ennius, ut noster cecinit, qui primus amœno
Detulit ex Helicone perenni fronde coronam.†

He painted Quevedo with spectacles,¹ which he

*'It is but mortal, the work you ask of me; but my quest is glory through all the years, to be ever known in song throughout the earth.' (trans. Showerman) † 'As our Ennius sang, who first bore down from pleasant Helicon the wreath of deathless leaves.' (trans. Bailey)

1. Lost, but known through copies

usually wore, so that the Duke of Lerma said in a ballad he wrote in reply to a sonnet sent him by Don Francisco de Quevedo asking for the gift of a sphere and a case of mathematical instruments:

Lisura en verso, y en prosa,
Don Francisco, conservad,
ya que vuestros ojos son
*tan claros como un cristal.**

Velázquez also portrayed His Excellency Don Gaspar de Borja y Velasco, Cardinal of the Holy Church with the title of Santa Croce in Gerusalemme, Archbishop of Seville and of Toledo and President of the Royal Council and of the Supreme Council of Aragón; the portrait is now in the palace of the Dukes of Gandía.[1] He also did the portrait of Don Nicolás de Cardona Lusignano, Master of the Chamber of our lord, King Philip IV.[2] The portrait of Pereyra of the Order of Christ, also Master of the Chamber, painted with singular mastery and skill, is also much celebrated.[3] He also

* 'Sincerity in verse and in prose maintain, Don Francisco, since your eyes are as clear as crystal'.

1. Lost 2. Lost 3. Lost

portrayed Don Fernando de Fonseca Ruiz de Contreras, Marquis of La Lapilla, Knight of the Order of Santiago, member of the Councils of War and of the Chamber of the Indies.[1] He painted another portrait of His Majesty in armour and mounted on a beautiful horse,[2] and after it was finished with his customary care, he wrote on a rock:

PHILIPPUS MAGN. HUIUS. NOM. IV.

POTENTISSIMUS HISPANIARUM REX,

INDIAR. MAXIM. IMP.

ANNO CHRIST. XXV SOECULI XVII.

ERA XX. A.*

And on a small stone he simulated a somewhat creased piece of paper that seemed stuck to it with sealing wax, painted from life with some care – as it itself demonstrates – for him to put his name on it after the painting had been exposed to everybody's criticism and opinion and he had considered the defects that, had been found in it, since he regarded

* 'Philip the Great, fourth of his name, most powerful King of the Two Spains, supreme Emperor of the Indies. Twenty-fifth year of the seventeenth century AD, twentieth year of his reign.'

1. Possibly a painting in the Gemäldegalerie, Dresden 2. Lost

the public as a more discerning judge than himself. Velázquez presented his work to public criticism, and the horse was censured for being done against the rules of art, but with such contradictory judgments that it was impossible to reconcile them. Annoyed at this, then, he wiped out the greater part of his painting and instead of his signature – since he had erased his work – he wrote,

*Didacus Velazquius, Pictor Regis, expinxit.**

I am not sure that the judgment was based on a profound knowledge of art, because not everything that appears defective to the eyes of the public is indeed so, any more than that which it praises as good is good indeed. In this respect, we see every day not only the ignorant public make mistakes, but also people of great erudition, quality, and good judgement. Which is why it is always dangerous to meddle in the affairs of others, because very often what looks to the public like rough sketches are marvels, to the professional. What I find admirable is the example Velázquez set for us with this action. For one thing, the modesty shown in erasing his work;

* 'Diego Velázquez, Painter to the King, erased [this].'

*The Surrender of Breda
('Las Lanzas'), 1634-5.
The figure on the extreme
right may be a self-portrait*

for another, his mistrust of pleasing. In leaving what had been criticized effaced, he was content with letting it be known that he had erased it himself, dispensing with the trouble of executing the same thing that he had already done. Because for it to be right, it would have had to be as it was before, and for it to adjust itself to ignorant corrections, it was better left effaced, since the variety of opinions made the undertaking impossible. This was very similar to what happened to Luca Giordano with the rendering of the horse that he executed in the picture for the Comendadoras de Santiago of this Court. Since he was painting it in the Hall of the Comedies of the Palace, the variety of opposing opinions concerning the proportions and the pose of the horse came to be so numerous that he could find no way of making them conform to the judgment of all those who considered themselves experts on this matter, and King Charles II (on the advice of a person of the profession) had to order him to leave it as it was, because otherwise it would never be finished. A very wise decision! For it is not the same to have knowledge about the handling of horses and about the proportions and bearing of their figure (if one can really accept such knowledge in everyone who claims it) as to have full understanding of the contours that the

various accidents of their movement present to the
eye and of the degree of their foreshortening, as well
as of how they are affected by distance and the sur-
rounding atmosphere. In his *Natural History* (Book
35), Pliny says that Alexander of Macedon went fre-
quently to Apelles's workshop (as we have said),
enjoying not only his artistry, but also his urbanity.
Once when he was in the workshop talking inexpert-
ly about many matters pertaining to art, Apelles told
him to heed some friendly advice and keep silent on
that subject, so the boys who ground his colours
would not laugh at him. That which Pliny writes
about Alexander, Plutarch refers to Megabizus in the
treatise in which he discusses the difference between
a flatterer and a friend. He says that once when the
Persian nobleman Megabizus, sitting next to Apelles,
was attempting to say something about contours and
shadows, Apelles said to him, 'Can't you see that the
boys who are grinding the yellow earth had their
attention fixed on you when you were silent a little
while ago, admiring the purple and gold that ennoble
you? Well, those same boys are now laughing at you,
when you start talking about things that you have not
learned.' Ælianus writes the same story, differing
only in that he tells it about the painter Zeuxis. It
may have been about him too, for one Megabizus is

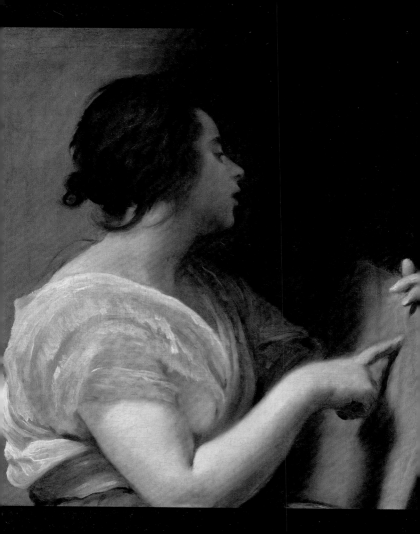

enough to annoy many Zeuxes and Apelles.

Velázquez's portrait, then, in the condition that I have described, was in the passageway that leads from the Palace to La Encarnación.

At this time, Velázquez also portrayed with utmost success a lady of singular perfection.[1] This portrait was the subject of an epigram by Don Gabriel Bocángel, which I have not wanted to omit for its great wit in pleasing the reader's taste in so few verses.

Llegaste los soberanos
ojos de Lisi a imitar,
tal, que pudiste engañar
nuestros ojos, nuestras manos.
Ofendiste su belleza,
Silvio, a todas desigual,
porque tú la diste igual,
*y no la naturaleza.**

He also painted the portrait of the venerable

* 'You have succeeded in imitating Lisi's sovereign eyes so well that you have deceived our eyes, our hands. You offend her beauty, Silvius, which is unlike any other, for you, and not Nature, have made its equal.' 1. Lost

Opposite: Sibyl with Tabula Rasa, c. 1648

Father Master Fray Simón de Rojas, outstanding man in learning and virtue, done after his death.[1] He portrayed himself as well on various occasions, notably in the painting of the Empress, of which special mention will be made.[2] During this period he also painted with singular excellence for the Hall of the Comedies in the Buen Retiro a large history painting of the taking of a fortress by Don Ambrogio Spinola.[3] He also painted another one of the *Coronation of Our Lady*, which was in the oratory of the Queen's Apartments in the Palace.[4] Besides many other portraits of famous men and jesters, which are in the stairs leading to the Garden of the Realms in the Retiro, by which Their Majesties come down to get their carriages.[5]

V. ACCOUNT OF THE SECOND JOURNEY TO ITALY TAKEN BY DON DIEGO VELÁZQUEZ BY ORDER OF HIS MAJESTY

In the year 1648, Don Diego Velázquez was sent to Italy by His Majesty on an extraordinary embassy to

1. Lost 2. *Las Meninas*, Madrid, Prado, ill. p. 23 and p. 144-5 3. *The Surrender of Breda*, Madrid, Prado, ill. pp. 106-7 4. Madrid, Prado 5. Six portraits of buffoons survive in the Prado

Opposite: The Buffoon Pablo de Valladolid, c. 1632

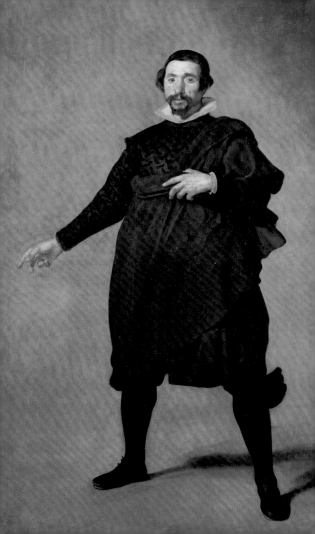

the Pontiff Innocent X and to buy original pa
and antique statues and make casts of some
most famous ones found in various places in
be it by Roman or by Greek artists. These can
ferentiated by the manner in which each work
by their use of dress, for the Romans usually
ed their images clothed and the Greeks nude, s
display the refinements of their art. This can l
in the works of Glycon of Athens in his sta
Hercules of Praxiteles,[1] of Phidias in the Buce
of Alexander the Great,[2] of Apollonius Neston
torso of Hercules that was so praised by M
angelo,[3] and in many other Greek statues.

Don Diego Velázquez, then, left Madrid
month of November of that year of 164
embarked in Málaga together with Don
Manuel de Cárdenas, Duke of Nájera, wl
going to Trent to wait for the Queen, our lady
Mariana of Austria, daughter of Emperor Fer
III and of Empress Doña María, Infanta of S

They arrived in Genoa, where they saw in
some works by Lazzaro Calvo and – in the
Maggiore del Consiglio – the portrait of

1. The *Farnese Hercules*, copied by Glycon, probably after
2. Uncertain but not by Phidias 3. The *Belvedere Torso*

Doria, the renowned sea captain, carved in marble by the hand of Fra Angelo da Montorsoli.[1] He is dressed in antique armour, with a baton in his hand and some Turks at his feet; it is six yards high and set on a great pedestal, the whole thing making up a formidable spectacle by its dimensions.

He then went to Milan, and although he did not stop to see the entry of the Queen, which had been prepared with great magnificence, he did not fail to see some of the excellent works of sculpture and of painting that are to be found in that city, such as the marvellous *Supper of Christ and His Apostles*, a work by the felicitous hand of Leonardo da Vinci.[2] In the end, he saw all the paintings and churches of that illustrious city.

He went to Padua and from there to the Republic of Venice, of which he was very fond because it is the workshop where so many excellent artists have been forged. He saw many works by Titian, by Tintoretto, and by Paolo Veronese, who are the artificers that he had chosen to follow and emulate since the year 1629, when he was in Venice for the first time.

There he had occasion to buy some ceiling

1. Partially destroyed; remains in San Matteo, Genoa. 2. *The Last Supper*, Sta Maria delle Grazie, Milan

paintings with scenes of the Old Testament by the hand of Jacopo Tintoretto. The principal one is oval in shape and in it are painted the children of Israel gathering the manna, as it is written in Exodus, everything marvellously executed.[1] He bought another picture of the *Conversion of Saint Paul*[2] and another one of *Paradise*,[3] attributed to Tintoretto, with a multitude of figures, great harmony and organization, and executed with the utmost facility and looseness; which is why it is thought to be by the hand of Tintoretto, as is the large one that he painted in Venice – the most praiseworthy among his works for its perfection and stupendous size – for which he must have executed this sketch. He also bought a *Venus and Adonis embracing*,[4] with a little Cupid at their feet, by the hand of Paolo Veronese, and some portraits.

By the same Veronese, he found two large pictures of scenes of the life of Christ; one was the miracle of the blind man to whom Christ restores his sight, and both were miracles of art. But because they were painted in tempera he did not dare bring them, considering that it was wiser to do without them than

1. Madrid, Prado 2. Perhaps the painting in Washington, National Gallery of Art 3. Madrid, Prado 4. Madrid, Prado

to make them run the risk of being damaged in the ship.

Velázquez took the road to Bologna to see the singular panel of *Santa Cecilia* with four other saints painted by Raphael of Urbino for San Giovanni al Monte,[1] the marble *Saint Petronio* by Michelangelo's hand,[2] and the bronze portrait of *Pope Julius II* above the door of San Petronio.[3]

He met with Michele Colonna and Agostino Mitelli, outstanding Bolognese fresco painters by whom there are many works in Italy that bear witness to their excellence, to arrange with them their coming to Spain.

Velázquez was lodged at the house of the Count of Segni, by whom he was very well entertained during the time he spent in Bologna and who, when Velázquez entered the city, had come out by carriage with other gentlemen more than a mile to receive him.

He went to Florence, where he found much to admire, for since the Dukes had always patronized the arts of drawing, from their illustrious academy had emerged such excelling talents as Dante

1. Bologna, Pinacoteca Nazionale 2. Bologna, San Domenico 3. In fact destroyed in 1511

Alighieri – no less a painter than a poet – and the divine Michelangelo Buonarroti – who alone would suffice to make it world famous. Having seen the most famous things of that sublime workshop of the arts and talents, he went on to Modena, where he was very favoured by the Duke, who showed him his palace and the curious and valuable things he owned, among them the portrait of the Duke that Velázquez had painted when he was in Madrid. The Duke sent him to see the palace and pleasure house that he owns seven leagues outside of Modena, painted in fresco by Colonna and Mitelli, all the walls covered with figures, compartments, cartouches, and ornaments done with such artistry that the onlooker can barely persuade himself that it is painting.

Velázquez went on to Parma to see Antonio Correggio's dome,[1] so famous throughout the world, and the paintings done by Mazzolino, the Parmigiano, each of whom added new lustre to his native city.

From here he started for Rome, and as soon as he arrived he had to go to Naples to talk to the Count of Oñate – Viceroy of that Kingdom at the time – who had orders from His Majesty to assist him freely and

1. In the Duomo

generously in all he needed for his purpose. He visited Jusepe Ribera (called il Spagnoletto in Italy), Knight of the Order of Christ, whose works in Naples were a credit to the Spanish nation.

He returned to Rome, where he was very favoured by the Cardinal Patron Astalli Pamphili, a Roman and nephew of Pope Innocent X, by Cardinal Antonio Barberini, by Abbot Peretti, by Prince Ludovisi, by Monsignor Camillo Massimi, and by many other gentlemen. He was also befriended by the most excellent painters, such as Cavaliere Mattia [Preti] of the Order of Saint John, Pietro da Cortona, and Monsieur Poussin, and by Cavaliere Alessandro Algardi, Bolognese, and Cavaliere Gian Lorenzo Bernini, both of them renowned sculptors.

Without neglecting his official business, Velázquez painted many things, chief among them being the portrait of His Holiness Innocent X,[1] from whom he received great and notable favours. In remuneration, and wishing to honour him in recognition of his great talent and merit, the Holy Father sent Velázquez a gold medal with His Holiness's image in low relief hanging from a chain. Velázquez brought to Spain a copy of this portrait.[2] It is said about it

1. Rome, Galleria Doria-Pamphilij 2. London, Wellington Museum

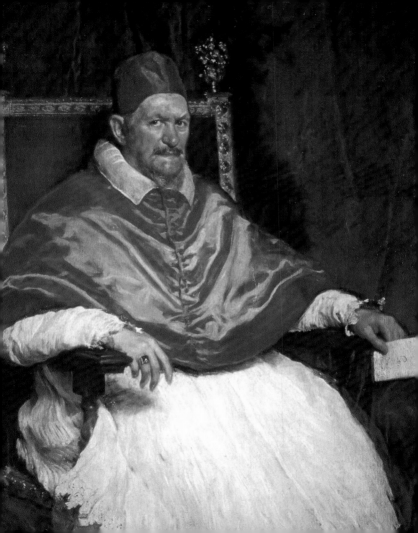

that when it was finished and was placed in a room past the antechamber of that palace, His Holiness's Chamberlain was about to enter it when he saw the portrait (which was in dim light) and, thinking it was the original, went back out again, telling the various courtiers who were in the antechamber to speak softly because His Holiness was in the next room. Velázquez portrayed Cardinal Pamphili,[1] the illustrious Donna Olimpia,[2] Monsignor Camillo Massimi, Chamberlain of His Holiness and an eminent painter,[3] Monsignor Abbot Hippolito, also the Pope's Chamberlain,[4] His Holiness's Monsignor Majordomo,[5] Monsignor [sic] Michelangelo, the Pope's barber,[6] Ferdinando Brandano, Chief Officer of the Pope's Secretariat,[7] Girolamo Bibaldo,[8] and Flaminia Triunfi,[9] excellent painter. He painted other portraits that I do not mention because they remained sketches, although they did not lack resemblance to their originals. All these portraits were painted with long-handled brushes in the spirited manner of the great Titian and are not inferior to his heads. This will not

1. New York, Hispanic Society of America 2. Lost 3. Kingston Lacy, Bankes Collection 4. Lost 5. Lost 6. Possibly a painting in a private collection, New York 7. Lost 8. Lost 9. Lost

Opposite: Innocent X, 1649-50

be doubted by anyone who sees those painted by his hand in Madrid.

When it was decided that Velázquez should portray the Pontiff, he wanted to prepare himself beforehand by painting a head from life as an exercise. He made the portrait of Juan de Pareja, his slave and a fine painter, which was so like him and so lively that, when he sent it by means of Pareja himself to some friends for their criticism, they just stood looking at the painted portrait and at the original in awe and wonder, not knowing to whom they should speak or who would answer them.[1] About this portrait (which is half-length and done from life) Andreas Schmidt, a Flemish painter in the Court who was in Rome at the time, used to tell that since for the feast of Saint Joseph it was the custom to decorate the cloister of the Rotunda* (where Raphael of Urbino is buried) with famous pictures, both ancient and modern, this portrait was hung there, and it received such universal acclaim that in the opinion of all the painters of different nations everything else looked like painting, this alone like reality. On the strength of this Velázquez was received as a Roman Academician in the year 1650.

* i.e. the Pantheon 1. New York, Metropolitan Museum

Opposite: Juan de Pareja, 1649-50

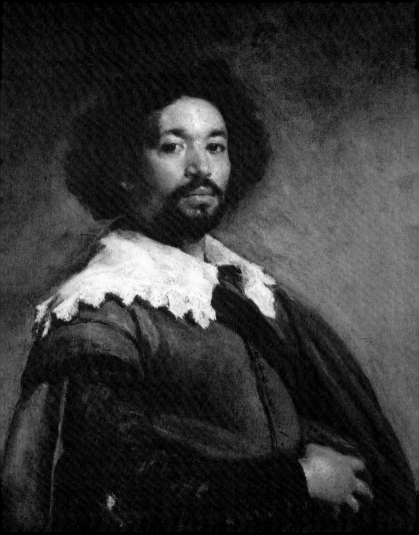

Velázquez decided to return to Spain on account of the frequent letters he received from Don Fernando Ruiz de Contreras, in which His Majesty ordered him to return.

Among the principal statues he chose from among so many was that of the Trojan Laocoön with his two sons, encircled by the intricate coils of two serpents that girdle them with marvellous knots, which is in the Belvedere.[1] Of these three statues, one is shown in a state of great pain, another in the act of dying, and the third of feeling compassion. Pliny says that it is a work worthy of being preferred and set above all other works of painting and of sculpture and that it was made from a single block – with the agreement and advice of the Senate of Athens – by three excellent artists: Agesander, Polydorus, and Athenodorus, all Rhodians. Pliny recounts this in elegant words and with great enthusiasm.

He also chose a beautiful colossal statue of a Hercules (which is called the Old Hercules) resting on a tree trunk – both from a single piece of marble – the Nemean lion's skin on him and the club in his hand.[2] The legs and the hands are modern, done by

1. The *Laocöon*, still in the Vatican 2. The *Farnese Hercules*, now in the Museo Nazionale, Naples. These casts are now lost.

Guglielmo della Porta from Porlezza, a distinguished sculptor and architect. On the trunk are carved some Greek letters which mean that Glycon of Athens made that statue. Another was of Antinous standing nude, which some say is Milon instead, complete but for a missing arm.[1] It was so revered by Michelangelo Buonarroti that he did not dare replace the arm. He has a sash wrapped around his left shoulder. Antinous was a very beautiful youth, the friend (in an immodest way) of Emperor Hadrian.

He brought another statue, or marvellous image, of the river Nile of Egypt, resting on his left side upon a sphinx.[2] On his left hand is the cornucopia of Plenty, and all over him are seventeen children, made from the same block of marble. On the base are carved crocodiles and various kinds of animals from Egypt that lurk in the Nile itself. This admirable sculpture was found near Santo Stefano del Cacco and is mentioned by Pliny.

He also brought the statue of Cleopatra with her right arm over her head,[3] who seems to be faint and dying from the poison introduced into her breast by the bite of an asp, with which she chose to take her

1. Uncertain 2. Vatican 3. Vatican, now known as the *Ariadne*. The cast bought by Velázquez is still in the Prado

own life rather than fall into the hands of her enemy, Augustus, who had already triumphed over her and her lover, Mark Anthony. Another one was of a standing Apollo, nude and with drapery around his shoulders and over his left arm.[1] He is shown after having shot an arrow, but the bow is broken. The quiver hangs from a strap around his neck, and his right hand rests on a marble tree trunk, that has a serpent around it. It is praised as the work of some excellent Greek sculptor. And also a very beautiful nude Mercury, who has the winged cap on his head, the caduceus in his left hand, and a pouch in his right, because the ancients made Mercury the god of eloquence, of trade and profit, and ambassador of the gods.[2] He also brought another statue of Niobe in the act of running, dressed in a very thin garment that seems to be moved by the wind.[3] She has her right arm raised, and with her left she gathers up a mantle that is wrapped around it.

He also purchased the statue of Pan, god of the shepherds, naked except for an animal pelt wrapped around him.[4] He is resting against a tree trunk on which one can see a flute carved. And one of an old faun, god of the forests and woods, with a child in his

1. *Apollo Belvedere*, Vatican 2. *Ludovisi Hermes*, Rome, Museo Nazionale delle Terme 3. *Niobid*, Florence, Uffizi 4. Uncertain

arms. He is standing naked, leaning on a tree trunk, and has a tiger skin wrapped around him.[1] He also brought a statue of Bacchus, nude, leaning against a tree trunk, with a dog eating grapes at his feet.[2] And a nude Venus when she was born from the sea.[3] Below her she has a dolphin with sea foam in its mouth and some little Cupids on its back. It is a very famous statue, smaller than life size and of singular beauty, for it does not need a soul to seem alive. Also another statue of a naked man with his right arm raised and fist clenched. He holds his clothes with his left hand, and there is a turtle at his feet.[4] It is said that it represents someone playing the game of *morra*, and the owner of the original in Rome believes it to be so. Others say that it is the Consul Brutus, who was the leader of the conspirators against Julius Cæsar. He also brought a small statue of a nymph, half-draped, leaning on her left arm upon a rock on which is carved a shell, and it is believed to be the goddess Venus.[5]

Another statue was of a naked man dropping to the ground as if in a faint.[6] He has a thick rope

1. Uncertain 2. Uncertain 3. Uncertain 4. Uncertain 5. *Nymph with a Seashell*, Paris, Louvre; the bronze cast is still in the Prado 6. *Dying Gaul*, Rome, Museo Capitolino

Overleaf: Venus and Cupid, known as the Rokeby Venus, c. 1647-51

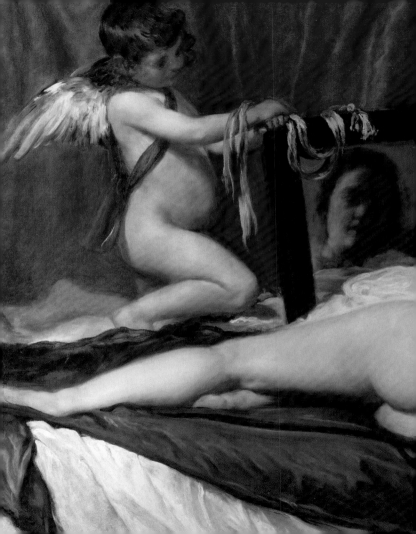

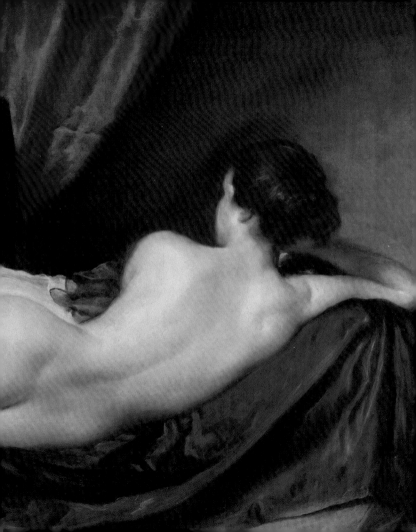

around his neck, and his weapons are down on the ground. It is held to be a gladiator sentenced to death, but others believe it may be one of the three Alban Curiatii brothers, who fought against the three Roman Horatii for the freedom of their country and were defeated and killed, leaving the Alban lands subject to the Romans. He also brought a nude Hermaphrodite resting on a couch; he who the poets tell was fashioned by the union of the nymph Salmacis (companion of the Naiads) with the son of Mercury and Venus (a youth of singular perfection) when the gods – at the entreaty of the nymph Salmacis – transformed the two of them into one being who retained the outward signs of both sexes.[1] It is the most beautiful statue one can imagine. He brought another of a standing Hermaphrodite and a small statue of the goddess Vesta and another of a naked nymph with a shell in her hands as if she were pouring water, held to be Diana.[2]

He also brought one of a struggle between two naked men who are no doubt gladiators, smaller than life size, done by an excellent artist; also a standing gladiator in fierce and violent motion, a Greek work, as is shown by the Greek inscription that is carved on

1. The *Hermaphrodite*, Paris, Louvre; the bronze cast is still in the Prado 2. None of these is identifiable with certainty

a marble tree trunk, which means in our language that Agasias Dositheus had it erected. This gladiator has seated next to him a naked man with a sword in his hand, and at his feet is a small boy with a bow in his hand, and a shield and helmet are on the ground.[1] It is a very beautiful statue and very lifelike, so much so that it seems to breathe. It is believed to be one of those gladiators who in ancient times went to the palestra of their own free will, with their weapons in their hands, and risked endangering their lives for a paltry sum.

He also brought a statue of a nude Mars with only a helmet on his head, standing and with a sword in his hand. Also a nude Narcissus, standing with open arms, in love with himself and the beautiful form he sees under the water, which he thinks is a living body. This mad passion cost him his life, so he was transformed into a flower named after him, thus fulfilling the prophecy of the soothsayer Tiresias. Velázquez also brought the image of a goddess of gigantic size, holding in her left hand a wreath of leaves tied with a ribbon and with the other lifting her dress – which is thin and delicate – and uncovering her feet.[2] Her arms are bare and so is part of her breast; on her

1. The *Seated Mars*, Rome, Museo delle Terme 2. None of these is identifiable with certainty

shoulders are some little buttons that fasten her dress, and she is girdled by a ribbon with a small bow. It is made of marble by the hand of a noble artist and is thought to be the goddess Flora. He also brought a young Bacchus, nude, leaning against a tree trunk where he has his robe; his right arm is raised, and he holds in his hand a bunch of grapes.[1] Also a nude figure pulling a thorn from his foot with great attention and care,[2] an unknown draped goddess who is held to be Ceres but has no attributes,[3] [and] a large lion, his neck and shoulders covered by a heavy mane, displaying his ferocity and nobility.[4]

He brought many portraits[5] as well (draped, in armour, and naked), such as that of Hadrian, Trajan's successor, who was an excellent prince and loved all the arts – so much so that he was architect, sculptor, and musician – and who was more famous for military discipline than for anything else, that of Marcus Aurelius, philosopher and Emperor, that of Livia, Cæsar Augustus' wife and mother of Emperor Tiberius, that of Julia, daughter of Julius Cæsar and wife of the great Pompey, that of Faustina, those of

1. Madrid, Prado 2. The *Spinario*, Rome, Museo Capitolino; the bronze cast is still in the Prado 3. Uncertain 4. Uncertain 5. A number of original Roman portrait busts survive in the Prado

Numa Pompilius, Septimius Severus, Antoninus Pius, Germanicus, Domitian, and Scipio Africanus, that of Titus, son of Vespasian, a courteous prince who defeated the Jews and destroyed the city of Jerusalem in revenge for the death of Christ, and many other emperors, consuls, and a great number of heads of men and women from the neck up. He also brought the head of the *Moses* by Michelangelo that is in the tomb of Julius II in San Pietro in Vincoli, about which the Cardinal of Mantua said that this figure alone was enough to honour Pope Julius II, such is its grandeur and majesty.

The desire to see Paris impelled Velázquez to try to return to Spain by land, but he decided not to do it because of the anxiety caused by the war, even though he had a passport from the French Ambassador. He embarked in Genoa in the year 1651, punctually obeying His Majesty's orders, as he always did, and although he was opposed by many heavy storms he arrived in the port of Barcelona in the month of June. He went on to Madrid and put himself at His Majesty's feet, who honoured him by saying in a letter written with his royal hand to Don Luis Méndez de Haro, among other things, 'Señor Velázquez has arrived and has brought some paintings,' etc. This is mentioned by Don Bernardino

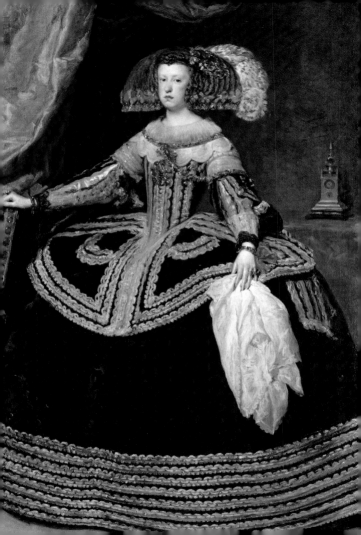

Tirado de Leiva in the settlement of the lawsuit over the salary of a soldier of this city.

During Velázquez's absence, Queen Isabel of Bourbon died, and the King made a second marriage to the Most Serene Queen Doña Mariana of Austria. She landed in Denia and, after celebrating her marriage to the King in Navalcarnero, entered Madrid in the year 1649, so that Velázquez, who returned from Italy in the year 1651 (having left in 1648), did not attend these functions.

Next it was time to make the casts of the statues, which was done by Girolamo Ferrer, who was outstanding at this and came from Rome to that effect, and Domingo de la Rioja, an excellent sculptor of Madrid. Some were cast in bronze to go into the octagonal room that had been designed and decorated by Velázquez. Velázquez also designed the decoration of the great hall and of the stairs of the Rubinejo, down which Their Majesties descend to get to their carriages. The choice of this staircase was worthy of his ingenuity, for before this Their Majesties had gone down to their carriages through the corridors and the principal staircase until they reached the vestibules. The rest of the statues were

Opposite: Queen Mariana, 1652

135

cast in plaster and were placed in the Crypt of the Tiger and in the Lower Gallery of the North Wind and in other places.

VI. IN WHICH HIS MAJESTY PHILIP IV HONOURS VELÁZQUEZ WITH THE APPOINTMENT OF CHIEF CHAMBERLAIN OF THE PALACE

In the year 1652, His Majesty honoured Velázquez with the appointment of Chief Chamberlain of his Imperial Palace, as successor in this office to Don Pedro de Torres. He continued to hold it – carrying it out to His Majesty's complete satisfaction and pleasure – until the year 1660, when he died. He was succeeded by Don Francisco de Rojas y Contreras, His Majesty's Secretary and Gentleman of the Bedchamber, who had formerly held the same office in Flanders under Cardinal Infante Ferdinand of Austria.

Concerning this office of Palace Chamberlain, Gil González Divila, Chronicler of His Catholic Majesty our lord King Philip IV, tells us in great detail in his *Teatro de las grandezas de Madrid* about

Opposite: Philip IV, 1656

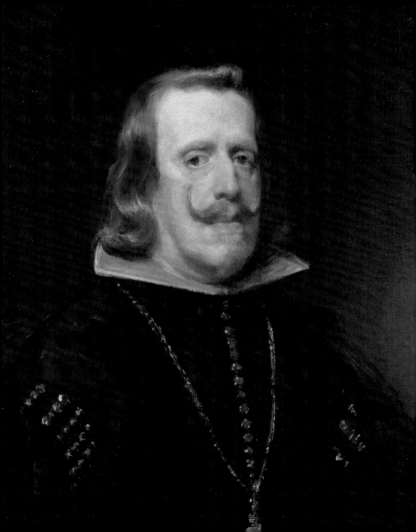

the conditions, duties, and privileges that come with it. It was a great honour for Velázquez, although some think that this is a matter that needs deeper reflection, for it would seem that the reward of professional men should be attended to very differently from that awarded for other kinds of merits or services. Because if it is given to men without occupation, giving them some way in which to serve is increasing their merit by their reward, but in men with a profession, such reward robs them of their merit, for if it was based on the exercise of their profession, they will be very hard put to continue earning it if they have no opportunity to practice that profession. Thus, it seems that the rewards given to artists should be purely honorary and pecuniary (when this is personally necessary): honorary as a stimulus and reward for their accomplishments, and pecuniary so that they may pursue at ease the most recondite beauties of their art, attending only to the interest of the fame awarded by posterity; and they should be given ever more opportunities to contribute to their own honour through the fine fruits of their study, for that is the reward that best affirms the excellence of the artist. For to suspend the practice of their profession, even by honourable employment, is the sort of reward that seems to

wear the disguise of punishment. If he who has been delinquent in the management of his office is suspended from its exercise, how can it be that what for some is a punishment should be a reward for others? We take into account that what is most precious about such an honour is serving the King, but let those who obtained their Sovereign's favour by following a certain line serve him along the same, and not in others that are quite foreign to the course of their abilities, because no matter how adept these men may be for such tasks, they waste that which is most precious in serving and in deserving. For any moderate talent is capable of domestic services with no more study than common practice, but not everybody is capable of some higher skill. Nature herself seems to show us how hard it is for her to bring forth an eminent man by failing in as many as we see remain in the foothills of different disciplines, unable to set foot on the summit of eminence. And, finally, many will be found to equal and even surpass the most celebrated artist for service in any domestic employment, but very few or perhaps none will be found to do a work of rare talent. Therefore, it would be a wise notion to use a person for that in which he may be unique, and not for that in which he is only ordinary.

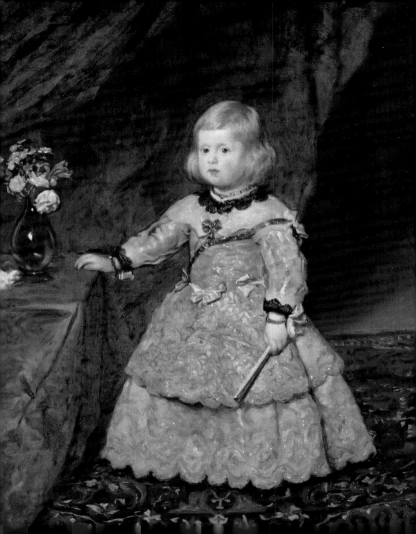

His Catholic Majesty King Charles II made a good practice of this, for having granted Luca Giordano almost countless favours – for himself and for his family – he never granted him one that would impede the course of his talent. To the contrary, he tried to stimulate it by always providing more opportunities for it to bear fruit in the embellishment of his palaces, chapels, and churches. Even the key of Keeper of the Keys (who is the Assistant to the Chamberlain, a position with which His Majesty honoured him when he came to Spain) was only for the honour of having free entry, and he was spared the burdens of its service.

The position of Chief Chamberlain of the Palace, in addition to being a great honour, is so onerous that it needs a whole man to fill it, and although we painters take so much pride in Velázquez's elevation to such honourable posts, we are also saddened to have missed many more proofs of his rare skill, which would have multiplied his teachings for posterity. But Velázquez's personal aptitude for any manner of employment and the high opinion that His Majesty had formed both of his virtue and of his talent made him worthy of the highest honours, because all seemed too small for the vast profusion of his merits.

Opposite: The Infanta Margarita in pink aged two, c. 1653

Don Diego Velázquez was held in such high regard as a person by His Majesty that he confided more in him than a King usually does in his vassal and discussed with him difficult matters, especially during those more intimate hours when the noblemen and other courtiers have retired. As proof of this, it happened that a certain son of a great gentleman, due to the ardour of youth, had some rather intemperate words with Velázquez because the latter had not wanted to relax some formality of his office, and having told his father about it – thinking to have done something amusing – his father told him, 'Have you committed such a breach with a man whom the King holds in such high regard and who spends whole hours in conversation with His Majesty? Go, and unless you give him complete satisfaction and regain his friendship, you need not return to my presence.' Such was the high opinion that even noblemen had of him, and it was as much as Velázquez rightfully deserved – for his deportment, his person, his virtue, and his honourable conduct – in spite of crass envy, which never rests, for it is always preying on the splendour of others, a necessary affliction of the fortunate, which only the unfortunate are spared.

VII. IN WHICH THE MOST ILLUSTRIOUS WORK OF VELÁZQUEZ IS DESCRIBED

Among the marvellous paintings made by Don Diego Velázquez was the large picture with the portrait of the Empress – then Infanta of Spain – Doña Margarita María of Austria when she was very young.[1] There are no words to describe her great charm, liveliness, and beauty, but her portrait itself is the best panegyric. At her feet kneels Doña María Agustina – one of the Queen's Meninas [Maids of Honour] and daughter of Don Diego Sarmiento – serving her water from a clay jug. At her other side is Doña Isabel de Velasco – daughter of Don Bernardino López de Ayala y Velasco, Count of Fuensalida and His Majesty's Gentleman of the Bedchamber, also a Menina and later Lady of Honour – in an attitude and with a movement precisely as if she were speaking. In the foreground is a dog lying down, and next to it is the midget Nicolasito Pertusato, who treads on it so as to show – together with the ferocity of its appearance – its tameness and its gentleness when tried; for when it

1. 'Las Meninas', 1656, Madrid, Prado; ill. p. 23 and overleaf

Overleaf: Detail of 'Las Meninas'

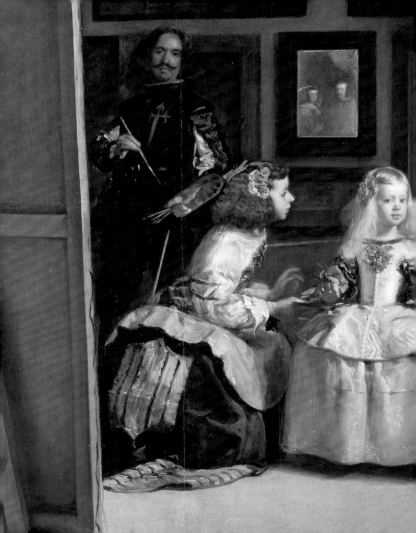

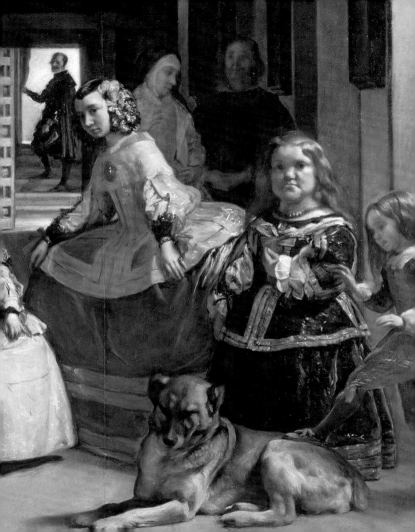

was being painted it remained motionless in what-
ever attitude it was placed. This figure is dark and
prominent and gives great harmony to the compo-
sition. Behind it is Maribárbola, a dwarf of formida-
ble aspect; farther back and in half-shadow is Doña
Marcela de Ulloa – Lady of Honour – and a Guarda
Damas, who give a marvellous effect to the figural
composition.

 On the other side is Don Diego Velázquez paint-
ing; he has a palette of colours in the left hand and
the brush in his right, the double key of the
Bedchamber and of Chamberlain of the Palace at his
waist, and on his breast the badge of Santiago, which
was painted in after his death by order of His
Majesty; for when Velázquez painted this picture the
King had not yet bestowed on him that honour. Some
say that it was His Majesty himself who painted it for
the encouragement that having such an exalted
chronicler would give to the practitioners of this very
noble art. I regard this portrait of Velázquez as no
lesser in art than that of Phidias, famous sculptor and
painter, who placed his portrait on the shield of the
statue of the goddess Minerva that he had made,
crafting it with such cunning that if it were to be
removed from its place, the whole statue would also
come apart. Titian made his name no less eternal by

portraying himself holding in his hands another portrait with the effigy of King Philip II[1] and just as Phidias's name was never effaced while the statue of Minerva remained whole, and Titian's as long as that of King Philip II endured, so too that of Velázquez will endure from century to century, as long as that of the lofty and precious Margarita endures, in whose shadow he immortalizes his image under the benign influence of such a sovereign mistress.

The canvas on which he is painting is large and nothing of what is painted on it can be seen, for it is viewed from the back, the side that rests on the easel. Velázquez demonstrated his brilliant talent by revealing what he was painting through an ingenious device, making use of the crystalline brightness of a mirror painted at the back of the gallery and facing the picture, where the reflection, or repercussion, of our Catholic King and Queen, Philip and Mariana, is represented. On the walls of the gallery that is depicted here and where it was painted (which is in the Prince's Apartments), various pictures can be seen, even though dimly lit. They can be recognized as works by Rubens and as representing scenes from

1. This painting was then in the palace of El Pardo near Madrid, where it was destroyed by fire

Ovid's *Metamorphoses*.[1] This gallery has several windows seen in diminishing size, which make its depth seem great; the light enters through them from the left, but only from the first and last ones. The floor is plain and done with such good perspective that it looks as if one could walk on it; the same amount of ceiling can be seen. To the left of the mirror there is an open door leading to a staircase, and there stands José Nieto, the Queen's Chamberlain; the resemblance is great despite the distance and the diminution in size and light where Velázquez assumes him to be. There is atmosphere between the figures, the composition is superb, the idea new; in brief, there is no praise that can match the taste and skill of this work, for it is reality, and not painting.

Don Diego Velázquez finished it in the year 1656, leaving in it much to admire and nothing to surpass. If he had not been so modest, Velázquez could have said about this painting what Zeuxis said about his beautiful Penelope, a work of which he was greatly satisfied: *invisurum aliquem, facilius, quam imitaturum,* that it would be easier to envy it than to imitate it.

1. In fact copies after Rubens by Martínez del Mazo, of which one, *Apollo and Marsyas*, survives in the Prado

Opposite: The Infanta Margarita in white aged five, c. 1656

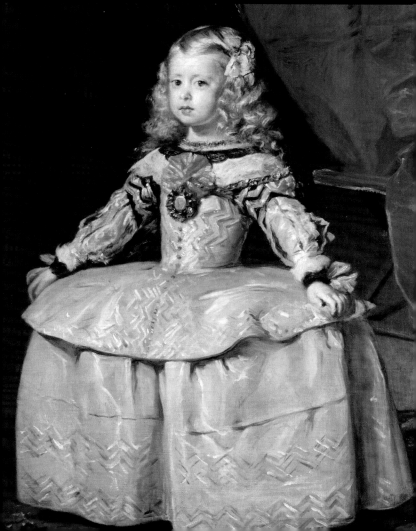

This painting was highly esteemed by His Majesty, and while it was being executed he went frequently to see it being painted. So did our lady Doña Mariana of Austria and the Infantas and ladies, who came down often, considering this a delightful treat and entertainment. It was placed in His Majesty's office in the lower Apartments, among other excellent works.

When Luca Giordano came – in our day – and got to see it, he was asked by King Charles II, who saw him looking thunderstruck, 'What do you think of it?' And he said, 'Sire, this is the Theology of Painting.' By which he meant that just as Theology is the highest among the branches of knowledge, so was that picture the best there was in Painting.

VIII. OF THE PAINTINGS THAT VELÁZQUEZ TOOK TO EL ESCORIAL BY ORDER OF HIS MAJESTY AND OF THE PAINTINGS IN THE GREAT HALL KNOWN AS THE HALL OF MIRRORS

In the year 1656 His Majesty ordered Don Diego Velázquez to take to San Lorenzo el Real forty-one paintings, in part from the estate sale of the King of England, Charles Stuart, first of that name, others brought by Velázquez and mentioned in section v,

and others given to His Majesty by Don Garcia Avellaneda y Haro, Count of Castillo, who had been Viceroy of Naples and at the time was President of Castile. Diego Velázquez made a description and report to show to His Majesty, in which he gives information about their quality, subjects, and authorship and the places where they are hung. This was done with such elegance and aptness that it gave proof of his erudition and great knowledge of art, for these works are so excellent that only from him could they receive the praise they deserved.

In the year 1657 Diego Velázquez wanted to return to Italy, but the King did not allow it on account of his dilatoriness the previous time. His Majesty wished, nonetheless, to have the ceilings and vaults of some of the rooms in the Palace painted in fresco – since this is the method of painting that is most suitable for walls and vaults and the longest lasting of all those used by painters and was much used by the ancients – so Michelangelo Colonna and Agostino Mitelli, with whom Velázquez had established contact in Bologna, as we said, came from Italy for that purpose.

They arrived in Madrid in the year 1658, where they were very well entertained and looked after by Don Diego Velázquez. He lodged them in the

Treasury House, in one of the principal apartments, and had charge of the wages paid to them every month, the disposition and settlement of which were also supervised by the Duke of Terranova as Superintendent of the Royal Works.

They painted the ceilings of three consecutive rooms in His Majesty's Lower Apartments. In one of them they painted *Day*, in another *Night*, and in the third the *Fall of Phaëton into the river Eridannus*, everything done with most noble form, actions, and artifice, and with excellent ornaments by the hand of Mitelli, who had a very special talent for this, as is attested to by all his works.[1]

In the same apartments they painted a gallery that looks on the Queen's garden. There Mitelli painted all the walls, linking at some points real and simulated architecture with such good perspective, art, and grace that it fooled the eye and made it necessary to resort to touching to be persuaded that it was only painted. By Colonna's hand were the simulated figures in full relief, the scenes in bronze bas-reliefs heightened with gold, the dolphins and boys of the fountains (which were also fictitious), the garlands of

1. All these paintings were destroyed by fire in 1734

Opposite: The Infanta Margarita in blue aged seven, c. 1659

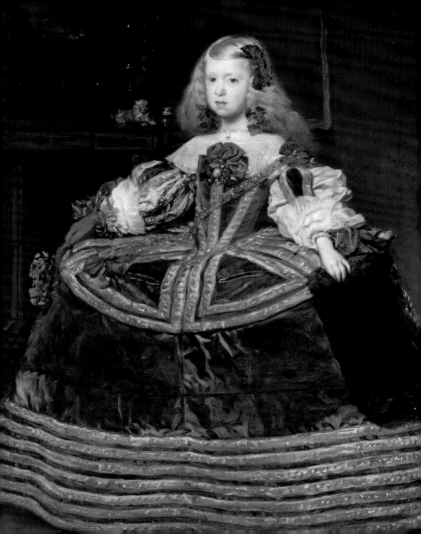

leaves and fruits, other moveable objects, and a little black boy descending a staircase who was painted to appear real, and a small, real window was introduced into the fabric of the feigned architecture. It should be noted that when those who looked at this perspective wondered whether the window was simulated (which it was not), they were also wondering whether it was real, this confusion being caused by the great realism of the objects that were simulated. But the vicissitudes of time deteriorated this building in such a way that it was necessary to repair it, forsaking those many beauties and marvels of art that I rated as such forty years ago, and I did not want the memory of them to perish.

At that time there were deliberations about what was to be painted in the Great Hall, which has its windows above the principal entrance to the Palace, and when the fable of Pandora was selected, Velázquez drew up the plan of the ceiling, with its divisions and the shape of the paintings, and wrote in each compartment the scene that was to be painted there.

This work was started in the month of April of 1659. It fell to Don Juan Carreño to paint in fresco the god Jupiter with Vulcan – his blacksmith and chief engineer – showing him the statue of a woman that Jupiter had ordered him to fashion with the

utmost perfection of which his talent was capable
and where Vulcan had spared nothing of his knowl-
edge so that he brought forth a prodigious statue of
singular beauty. Farther back he painted the forge
and workshop of Vulcan, with its anvils, double
anvils, and other smithy's tools, and at work in it the
cyclops who were his journeymen, whose names
were Brontes, Steropes, and Pyracmon.

It fell to Michelangelo Colonna to paint the scene
in which Jupiter commanded the gods each to bestow
upon her some gift, so that she would become still
more perfect. Apollo endowed her with that of
music, Mercury with those of discretion and elo-
quence; in brief, each one with whatever was his own
to give. And because she had acquired so many gifts
from the gods, they named her Pandora in Greek,
from *pan*, which means 'all,' and from the word *doron*,
which means 'endowment,' so that the two names
together mean 'endowed with all'. The gods and
goddesses can be seen beautifully placed on thrones
of clouds, with their own attributes by which to iden-
tify them, Jupiter on his eagle presiding over them all,
and Pandora and Vulcan below. This is the principal
scene, and it is in the centre of the ceiling. its shape
is somewhat oval, and that of the whole ceiling some-
what concave.

It fell to Don Francisco Rizi to paint Jupiter giving Pandora a precious gold vessel, while telling her that inside was the dowry for her support and that she should look for Prometheus, who was a person worthy of her, and provide for her dowry with what she was taking.

Elsewhere he painted Pandora offering the gold vessel to Prometheus, who rejects her with a very lively action and movement, not wishing to hear her out; for being as discreet and prudent as he was, he realized that she was not real, and her composure, ease, and effectiveness in persuasion were somehow feigned. Farther back are Hymen, god of marriage, and a little Cupid going out the door, seeing that his weapons are useless there. Since Prometheus knew that Pandora was going to meet his brother Epimetheus, he warned him and advised him – for he was younger and not too experienced – that if perchance that woman came to his door, he should on no account let her in, because she was a deceiver. Pandora went to Epimetheus' house at a time when she knew that Prometheus was absent, and she was able to compel him to such a degree with the flattery of her sweet words and to persuade him so effectively that he married her, without heeding his brother's advice or considering the consequences that might

result from it by way of the afflictions, anxieties, and other things that marriage brings with it. Carreño started to paint this wedding of Epimetheus and Pandora, but when it was far advanced he was checked by a very serious malady, and it was therefore necessary for Rizi to finish it. The scenes in the simulated gold shields in the four corners of the room are also by Rizi. But after some years, since scaffolding had been erected to repair the damages done to this painting by a rainstorm, Carreño repainted in oils the said scene almost completely.

The decorations fell to Mitelli, who did them in such a grand manner, enriching them with such handsome architecture and such solid and massive ornament, that they seem to add strength to the building. What is also very worthy of the highest praise is the great facility and skill with which they are executed. Colonna painted some moveable objects: garlands of leaves, of fruits, of flowers, shields, trophies, and some fauns, nymphs, and beautiful children standing on the projection of the simulated cornice – which looks as if it were made of jasper – and a golden laurel wreath that encircles the

Overleaf: The Spinners ('Las Hilanderas')
or the Fable of Arachne, c. 1656-58

entire hall. The room turned out to be so beautiful that it delights the eye, entertains the memory, sharpens the intellect, satisfies the soul, spurs on the will, and, lastly, it proclaims with all: majesty, genius, and grandeur. The King went up every day – and sometimes also the Queen, our lady Doña Mariana of Austria, and the Infantas – to see the progress in the state of this work, and he asked the artists many questions with the love and affability with which His Majesty always treated the practitioners of this art.

Excellent drawings and cartoons were made for all these compositions at actual size on tinted paper – which served as the middle tone for the white highlights, a manner of drawing that is much admired and adopted by great artists. That is why Vasari said, 'Questo modo è molto alla pittoresca, e mostra più l'ordine del colorito.'* Those that Colonna made were extremely agreeable, because they looked coloured, the reason being that he heightened with gesso mixed with red earth on paper that was a natural blue, following the same order as in painting.

There are many painters who shirk making cartoons at actual size for works in oils, but it cannot be avoided for works in fresco, so that the work can be

* 'This method is very painterly and shows better the arrangement of the colours.'

divided up accurately and to scale and to see the effect of the choice and be able to judge the whole.

After Mitelli and Colonna had finished the work in the Palace, the Marquis of Heliche took them to the Buen Retiro to paint the Hermitage of San Pablo (the first hermit), which they did with no less grandeur and artistry. There they executed the *Fable of Narcissus* with admirable architecture, ornament, and columns that belie the concavity of the vault.[1] And in the oratory of the Hermitage there is a painting by Velázquez of the *Visit of Saint Anthony Abbot to Saint Paul the Hermit*, an excellent work.[2]

In a garden that the said Marquis of Heliche has in Madrid, near San Joaquín, they also painted many things, and one may admire a bowed Atlante by Colonna's hand – bearing on his shoulders a sphere with all the circles and celestial signs – which is executed with so much art that it looks like a free-standing statue and as if there were air between the wall and the figure. This is due to the shadow that it seems to cast upon the wall on account of the assumed light. They also painted on a fountain a decoration with two terms, a very fanciful thing, but all is now very damaged by the ravages of time. There were

1. Destroyed 2. Madrid, Prado

excellent works of sculpture and painting in this garden, but all have disappeared by now.

From there they were taken to the Convent of Nuestra Señora de la Merced to paint the whole church, and after both of them had come to an agreement with the monks about the work – on August 2 of the year 1660, a Monday and the feast day of Our Lady of the Angels – Agostino Mitelli died while he was painting the dome. The death of so illustrious a painter was regretted by the whole Court and was a great loss to the monks. He was buried with great solemnity in that very convent, and some very elegant verses were written on his death, as well as the following epitaph:

MEMORIAL TOMB
AND FUNERAL ELEGY
*at the Obsequies held for Agostino Mitelli,
composed to his ashes by an admirer,
in the name of the School of Art.*
D. M. S.
AGUSTINUS MITELLI
BONONIENSIS
Pictor præclarus, Naturae æmulus admirandis, de

Opposite: Visit of St Anthony Abbot to St Paul the Hermit, c. 1633

perspectiva incomparabilis, cuius manu prope vivevant
imagines ipsa invida, accubuit Mantuæ Carpentanæ,
postridie Kalendas Augusti,
Anno MDCLX
H.S.E.S.T.T.L.*

This work was suspended on account of that sad and unexpected occurrence. In the meantime, Colonna painted the ceilings of the Casa de la Huerta, built by the Marquis of Heliche on the road to El Pardo (owned today by the Marquis of Narros), where many other painters, Spanish as well as foreign, also worked. Don Juati Carreño and Don Francisco Rizi were in charge of this work. The best paintings that could be had – by Raphael, Titian, Veronese, Van Dyck, Rubens, Velázquez, and many others – were faithfully copied on the walls, in gilded frames that are also painted, as were some extraordinarily well simulated cloth hangings. On the exterior, the walls of the house were painted in fresco, and some clocks were designed for it with remarkable peculiarities that the sun would reveal on certain

* 'Agostino Mitelli of Bologna, illustrious painter, admirable rival of Nature, peerless master of perspective, whose hand made images come to life in the envy of Nature, died in Madrid on August 2, 1660.'

days, all of which is now in ruinous state due to the ravages of time.[1]

Although the work on La Merced was suspended for some time, the dome was finished with great success and to the whole Court's applause by Michele Colonna. For although he devoted himself to painting figures rather than decorative elements, it was not because he did not know how, but to leave for Mitelli the type of work at which he most excelled. Once he had finished, he left Madrid to go to Italy in the month of September of the year 1662, although some say that he went to France.

IX. WHICH DEALS WITH THE IMAGE OF THE HOLY CHRIST OF THE PANTHEON AND THE ARRIVAL OF MORELLI IN SPAIN

In the year 1659, there arrived in Spain the gilded bronze image of the *Crucified Christ* that the Duke of Terranova had commissioned in Rome by order of the King, for the royal chapel of the Pantheon, burial place of the Catholic Monarchs of Spain. The artist was a nephew of Giuliano Finelli (*alievo*, or

1. Now entirely vanished.

disciple, of Algardi). It was brought to the Palace in the month of November and was seen by His Majesty in the octagonal room. He then commanded Diego Velázquez to give orders for it to be taken to San Lorenzo el Real and to go there himself as well to see how it should be set in place. He did as His Majesty commanded.

In that year, Giovanni Battista Morelli, native of Rome, a famous sculptor and pupil of Algardi, came to Valencia from Paris on account of I know not what trouble he had had in France – where he had been a much esteemed sculptor of His Most Christian Majesty – which forced him to flee. He had modelled wonderful things in terracotta, in the round and in low relief, as can be seen in the compositions that he made in Valdecristo (one of the monasteries of the holy Carthusian Order in that kingdom) and in other things that I have seen in Valencia in the house of Don Juan Pertusa (Knight of the Order of Montesa and member of one of the most illustrious families in that city) and elsewhere, all of them done with such excellence that it seems as if Tintoretto had imbued him with his spirit and liveliness. He decided then to send some work by his hand to Don Diego Velázquez, as a protector of this art and as someone in whom the practitioners of all the arts

had always found due regard and assistance, as happened on many occasions of which I could make extensive mention. He therefore sent him a letter and with it some reliefs of winged children carrying the emblems of Christ's Passion. When Don Diego Velázquez and Juan Bautista del Mazo (his son-in-law and Painter to His Majesty and his Successor to the appointment of Painter to the Bedchamber) saw them, they judged them to be exceptional works and worthy of being looked at by His Majesty. They showed them to the King to his approval and great pleasure, so they were placed in the Palace – set in their frames – and were paid for by His Majesty by means of Velázquez. After this, having seen how well they had been liked, Morelli sent other terracottas and a large *Dead Christ* in full relief with some angels supporting him and weeping with great naturalness. He also sent a *Saint John the Baptist*,[1] a *Sleeping Christ Child*, and a half-length *Saint Philip Neri* in full relief, like the preceding works.

Velázquez wanted to see Morelli and bring him to the Palace to do some work, but although he wrote to him accordingly, [Morelli] was not able to come to Madrid until the year 1661 when, to his sorrow,

1. The *Infant St John the Baptist* is the only identified work by Morelli to survive; it is in the Prado.

Velázquez had already died. He brought a good number of small statues of the gods, observing in each those qualities for which the Greeks are unmatched: expression and vivid gesture in accordance with the person represented. If it is Orpheus playing his lyre, the music of the song is expressed by a little boy asleep to the sweet melody of its strains. Cybele with a crown of towers on her brow – for she was thus painted by the Ancients – manifests her greatness, for the poets wrote that she was the mother of all the gods, in Mercury, as the god of Peace, he expresses tranquillity of spirit, in Mars, fury, in Jupiter, power, and likewise in all the rest, such as Neptune, Vulcan, Saturn, and others, for all these statues are worthy of great regard and esteem. They were placed in one of the underground rooms of the Queen's garden in the Palace.

His Majesty commanded Morelli to deliver a figure of the god Apollo done from the model, naked but for a sash to make him decent and to his right a very beautiful child holding his lyre, because the Ancients attributed to him the art of music. His Majesty went down often to see him model and sculpt, and when this figure was finished it was set up in a garden. He made another terracotta statue of a Muse with a child by her side holding her musical

instrument. This was placed in a niche of the private staircase to the King's Apartments.

He made the model for the gilded bronze masks that are in the fountain that was made for Aranjuez in the year 1662, which has many water spouts and is adorned with many marble statues. The stucco ornaments that he had started in some of the rooms in that palace were left unfinished due to King Philip IV's death and also because he was not given adequate means. Morelli returned to Valencia with the intention of coming back later to finish them, as indeed he came; but death overtook him in Madrid, so they remained unfinished. He was outstanding, especially in working or modelling with clay.

X. HOW VELÁZQUEZ, BY ORDER OF HIS MAJESTY,
WAITED ON THE FRENCH AMBASSADOR EXTRAORDINARY
WHO CAME TO ARRANGE THE MARRIAGE OF THE MOST
SERENE INFANTA OF SPAIN, DOÑA MARÍA TERESA OF
AUSTRIA, AND ABOUT SOME PORTRAITS THAT
VELÁZQUEZ PAINTED AT THIS TIME

Going back, then, to the year 1659, on the 16th of October, the Maréchal Duc d'Agramont, Governor of Béarn, Bordeaux, and Bayonne, Ambassador

Extraordinary of the Most Christian King Louis XIV, entered Madrid to arrange the joyful nuptials of that King with the Most Serene Lady Doña María Teresa Bibiana of Austria and Bourbon, then Infanta of Spain. He entered the Palace under the sponsorship of the Lord Admiral of Castile, and His Majesty received them in the Hall, standing next to a writing table, and remained thus for the entire time the function lasted. The Hall of Mirrors was splendidly and richly decorated, and beneath the canopy there was a chair of inestimable value. The decoration was done under the direction of Don Diego Velázquez as Chief Chamberlain and of the Tapestry Keeper. Since Monsieur le Maréchal had wanted to see the King's Apartments at leisure, His Majesty ordered Don Diego Velázquez to wait on him with great solicitude, showing him whatever was most precious and- remarkable in the Palace. On Monday, October 20, at two o'clock in the afternoon, Monsieur le Maréchal entered the Palace through the private staircase that leads to the park's garden. He came accompanied by his two sons, the Count of Guiche, Field Marshal of one of the regiments of the Most Christian King, and the Count of Louvain, and by other gentlemen. Don Diego Velázquez showed them all the rooms in the Palace, where they found

much to admire on account of the multitude of original paintings, statues objects of porphyry, and other treasures with which its great fabric is adorned.

He likewise found much to admire in the palaces he visited, particularly those of the Admiral of Castile, of Don Luis [Méndez] de Haro, of the Duke Medina de las Torres, and of the Count of Oñate, who owns most excellent original paintings.

When Monsieur le Maréchal departed for France, he left with Don Cristóbal de Gavinia of the Order of Santiago, Captain-General of the Spanish Guards and Usher of Ambassadors, a very rich watch he was to give to Don Diego Velázquez.

In that year 1659, Velázquez executed by order of His Majesty two portraits to be sent to the Emperor in Germany. One was that of the Most Serene Prince of Asturias, Don Felipe Próspero, who was born on Wednesday, the 28th of November of the year 1657, at eleven thirty in the morning. It is one of the finest portraits he ever painted, despite the difficulty of portraying children on account of their liveliness and restlessness.[1] He painted him standing and in the clothes appropriate to his tender years; next to him, on a plain stool, is a hat with the white plumes; on the

1. Vienna, Kunsthistorisches Museum

other side there is a crimson chair on which he rests his hand lightly. In the upper part of the picture there is a curtain; at the back of the room is painted an open door, everything done with the utmost grace and art and with the beauty of colour and the grand manner of this illustrious painter. On the chair is a little bitch that seems alive and is the likeness of one for which Velázquez felt great affection. It seems that the same thing happened to him as to the excellent painter Publius, who portrayed his beloved little bitch Issa so as to make her immortal, as Martial wittily says, and he could have also said it about Velázquez:

> *Hanc, ne lux rapiat suprema, totam,*
> *Picta Publiu exprimit tabella;*
> *Inqua, tam similem videbis Issam.*
> *Ut sit tam similis sibi, nec ipsa.*
> *Issam denique pone cum tabella:*
> *Aut utramque putabis, esse pictam;*
> *Aut utramque putabis, esse veram.**

* 'So that death should not rob him of her completely, Publius portrayed her in a picture, in which you will see an Issa so like her that not even she is so like herself. Put Issa alongside her picture: you will think that they are both painted; you will think that they are both real.' Martial, *Epigrams*, 1, 10.

Opposite: The Infante Felipe Próspero, 1659

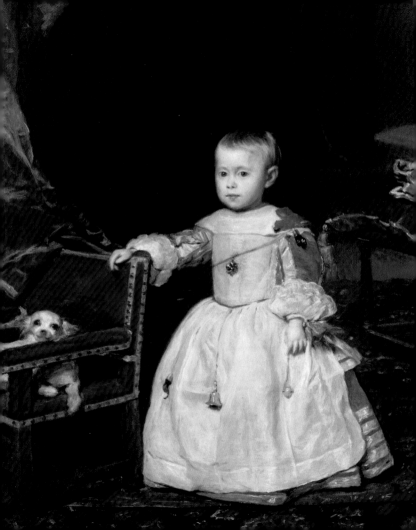

The other portrait was of the Most Serene Infanta Doña Margarita Maria of Austria, excellently painted and with the majesty and beauty of the original.[1] To her right, sitting on a small console table, there is an ebony clock of very elegant design, with bronze figures and animals; in its centre there is a circle where the chariot of the sun is painted, and within the same circle there is a smaller one with the division of the Hours.

At this time he made another portrait of our lady, the Queen, on a circular sheet of silver of the same diameter as a Segovian *real de a ocho*, where he showed himself to be no less ingenious than subtle, for it was very small, highly finished, and an extremely good likeness, and was painted with great skill, persuasiveness, and delicacy.[2] And it surely seems that whoever can infuse in such a small space as much spirit as one can see in this portrait would make Nature jealous, if she were capable of jealousy. Velázquez deserves immortal fame with even greater reason than Marcellus deserved praise as a famous sculptor for having carved out of a cherry stone a ship with all its rigging, such that if a bee was placed on its lateen yard, it covered the ship entirely with its

1. Vienna, Kunsthistorisches Museum, ill. p. 153 2. Lost

wings. This work caused so much wonder that on its account – according to Cicero – the people wanted Marcellus to be counted among the gods, when it is a fact that this can be achieved by anyone who, together with keen eyesight, has an ocean of phlegm, whereas a delicate painting that looks as if it had a soul is achieved only by someone who is profoundly talented, through long study and many years' practice.

Seldom did Don Diego Velázquez pick up his brushes after this, so we can say that these portraits were his last works and the ultimate in perfection by his eminent hand, which raised him to such exalted esteem and regard.

Having been as greatly favoured by fortune, Nature, and genius as he was, besides being greatly envied, he was preserved from ever being envious himself. He was very witty in his remarks and repartee. His Majesty told him one day that there were some people who said that all of his ability was limited to knowing how to paint a head, to which he replied, 'Sire, they flatter me greatly, for I do not know of anybody who knows how to paint one.' Remarkable result of envy toward a man who had demonstrated his universal understanding of the art [of Painting] with such supreme proofs as were his

history pictures, in which he left as many lessons to posterity!

XI. OF THE MOST OUTSTANDING HONOUR THAT HIS MAJESTY CONFERRED UPON DIEGO VELÁZQUEZ AS A REWARD FOR HIS MERITS AND SERVICES

In the year 1658, when Don Diego Velázquez was in El Escorial with the King, His Majesty, in consideration of his talent, ability, and personal merits and of other services performed by Don Diego Velázquez that made him worthy of further advancement, honoured him one day during Holy Week by conferring upon him the habit of any one of the three Military Orders that he should choose. Velázquez chose that of the Military Order of the Knights of Santiago, and if death had not overtaken him, this would have been the beginning of his rise to greater honours, Such was his personal aptitude, which offered the materials with which to build even greater fortunes.

I have heard from completely trustworthy people that when the King learned that the proceedings of the Proofs had been protracted on account of an impediment created by envy – of which there was a great deal – he ordered the President of the Orders,

the Marquis of Tabara, to send him the reports in Velázquez's Proofs in which His Majesty had to testify, and when they arrived the King said, 'Write down that I am certain of his nobility,' with which no further inquiry was necessary. O magnanimity worthy of a great King, perfecting with his own hand the work that he had fashioned and that others sought to tarnish and at the same time sparing Velázquez the embarrassment of the delay and the great expense of a new report! At last it was approved by the Council of the Orders on Thursday, November 27, and on Friday, feast day of Saint Prosper Martyr and 28th of that month and year, in the convent of the Nuns of Corpus Christi, Velázquez received the habit from the hands of Don Gaspar Juan Alonso Pérez de Guzmán the Good, Count of Niebla and later Duke of Medina-Sidonia, with the customary ceremonies and to the great satisfaction.of all. His sponsor was His Excellency Don Baltasar Barroso de Ribera, Marquis of Malpica, Commander of the Order of Santiago.

He was taken back to the Palace and was very well received by His Majesty, and by all the gentlemen and servants of the King's Chamber. This was a very festive day in the Palace because it was Saint Prosper's day, birthday of the Most Serene Prince

Prospero, and thus Velázquez could interpret every-
thing as signs of its auspiciousness, even his having
experienced on this occasion the opposition of envy,
for opposition perfects virtue, whereas its splendour
is belied if it lacks darkness against which to shine.
His natal horoscope had undoubtedly been a happy
and propitious one, like the one described by Julius
Firmicus, in which he who is born to it will excel
in painting and through it be ennobled with high
honours.

Don Lázaro Diaz del Valle wrote a eulogy and
catalogue of some painters who have been honoured
with the habits of the Military Orders for their great-
ness and he dedicated it to Don Diego Velázquez.

XII. OF THE JOURNEY THAT VELÁZQUEZ MADE WITH
HIS MAJESTY AND OF HIS ILLNESS AND DEATH

In the month of March of the year 1660, Don Diego
Velázquez left Madrid to prepare lodgings for our
great Monarch Philip IV in the journey, that His
Majesty was making to Irún to accompany the Most
Serene Infanta of Spain, Doña María Teresa of
Austria. Don Diego Velázquez left Madrid some days
before His Majesty, taking with him José de Villareal,

Keeper of the Keys and Chief Architect of the Royal Works, and other servants of His Majesty who were needed on the journey, all of them within his jurisdiction and under his orders. José Nieto went as Chamberlain of the Most Christian Queen.

The journey started by way of Alcalá and Guadalajara, and they arrived in Burgos, where Velázquez had orders from His Majesty to leave the Keeper of the Keys, since His Majesty had to stop in that city. The others continued on their way to Fuenterrabía, where Velázquez prepared lodgings for His Majesty in the castle that Baron Watteville, Governor of the city of San Sebastián, had already made ready. Velázquez was also in charge of the fabric of the Conference House that was erected on the Isle of Pheasants in the river Bidasoa, next to Irún in the province of Giupúzcoa. Don Diego Velázquez boarded a barge with the Baron to go to the Conference House, which is not far from Fuenterrabía, and see what its condition was, for it had been greatly enlarged from the form it had in 1659, when Cardinal Jules Mazarin and the Count-Duke of Sanlúcar had negotiated the peace between the Catholic King of Spain and the Most Christian King of France. He had orders from His Majesty to assist in the embellishment of this house and of the

castle and to be in the city of San Sebastián, where he was going to stop for a few days, by the time His Majesty arrived there. He returned with His Majesty to Fuenterrabía in the first days of June and assisted in all the functions held by His Majesty in the Main Hall of the Conference House, until Monday June 7, when the handing over of the said Most Serene Infanta to the Most Christian King, Louis XIV took place. Here I will make a pause, for a longer account and more elegant pen are needed to relate the grandeur and splendour that such great monarchs displayed on this happiest of days.

The presents of a Golden Fleece in diamonds, a gold watch ornamented with diamonds, and other precious and exquisite jewels of inestimable value that the Most Christian King made to His Majesty this day were given to Don Diego Velázquez to be taken to the palace of the Castle of Fuenterrabía.

Don Diego Velázquez was not that day the one who showed least consideration to the adornment, handsomeness, and splendour of his person, for in addition to his elegance and grace (which were courtly without his putting any effort into his natural grace and dress), he was ennobled by many diamonds and precious stones. It is not surprising that he should surpass others in the colour of the cloth, since he was

exceptional in his knowledge of fabrics, for which he had always shown great taste. His whole suit (which, although coloured, required a *golilla* even during a journey) was trimmed with rich Milanese silver point lace, according to the fashion of that time. On his cloak was a red insignia, and he had a very beautiful rapier with a guard and chape made of silver chased with exquisite relief work, fashioned in Italy. Also a heavy gold chain around his neck held by a badge set with many diamonds, on which the cross of Santiago was enamelled. The rest of the trimmings were in accord with such precious trappings.

On Tuesday June 8 His Majesty left Fuenterrabía with Velázquez in attendance, as His Majesty had commanded, and José de Villareal, the Keeper of the Keys, was sent ahead to prepare the lodgings. The return journey to Madrid was by way of the Guadarrama and El Escorial.

When Velázquez entered his house, he was received by his family and friends with more amazement than joy, for news of his death had spread through the Court, and they could hardly credit their eyes. It seems as if this was a presage of how little time he had left to live.

On Saturday, the feast day of Saint Ignatius of Loyola and the last of the month of July, after having

attended His Majesty all morning, Velázquez was bothered by a burning sensation, so that he was obliged to go home through the passageway. He started to feel great anguish and pains in the stomach and heart; he was visited by Doctor Vicencio Moles, the family physician, and His Majesty, concerned about his health, sent Doctor Miguel de Alba and Doctor Pedro de Chávarri, Physicians to His Majesty's Bedchamber, to look at him. Recognizing the danger, they said it was the beginning of a syncopal tertian fever (a very dangerous disease because of the great resolution of spirits it causes) and that the constant thirst he felt was a clear sign of the manifest danger of that mortal illness. By order of His Majesty, Don Alfonso Pérez de Guzmán the Good, Archbishop of Tyre and Patriarch of the Indies, visited him and delivered a long sermon for his spiritual solace. And on Friday, August 6 of the year of Our Lord 1660 on the day of the Transfiguration, after receiving the holy sacraments and having given power of attorney to make his will to his intimate friend Don Gaspar de Fuensalida, His Majesty's Keeper of the Records, at two o'clock in the afternoon and at sixty-six years of age, he gave up his soul to Him who had created him for the wonder of the world. He left behind great sorrow in

everyone, and not the least in His Majesty, who at the height of his illness had made it known how much he loved him and esteemed him.

They put on his body the humble undergarments of the dead and then dressed him as if he were alive, as is customary with the Knights of the Military Orders, with the capitular cloak, the red insignia on his chest, hat, boots, and spurs; and in this fashion he lay that night on his own bed in a room covered with crepe, with some large candelabra with tapers at either side and other candles on the altar, where there was a Crucifix. He remained there until Saturday, when his body was moved to a coffin lined with plain black velvet garnished and trimmed with gold passementerie and surmounted by a cross of the same garniture, with gilt nails and corner plates and with two keys. When night came and its darkness dressed everyone in mourning, he was taken to his last resting place, in the parish church of San Juan Bautista, where he was received by the Gentlemen of His Majesty's Bedchamber, who carried him to the catafalque that had been prepared in the middle of the presbytery. His body was placed on top of the catafalque, to either side of which were twelve silver candelabra with tapers and a great number of candles. The whole funeral service was conducted with

great solemnity, with excellent music from the Royal Chapel, which had the sweetness, measure, and number of instruments and voices that are customary at such solemn functions. Many noblemen and Gentlemen of the Bedchamber and servants of His Majesty were in attendance. The coffin was then brought down to the crypt and burial chamber of Don Gasper de Fuensalida, who, as a demonstration of his affection, had given him this place for his tomb.

The following epitaph was dedicated to Velázquez by his very dear and talented pupil Don Juan de Alfaro (illustrious Cordovan to whom the greatest part of this account is due), who had it printed. With the help of the great erudition of his brother, Doctor Enrique Baca de Alfaro, he compiled in these few lines what was too much to fit into so many years.

EPITAPH TO THE DEATH OF
DON DIEGO VELÁZQUEZ

POSTERITATE SACRATUM

D. DIDACUS
VELÁZQUEZ DE SILVA

Hispalensis. Pictor eximius, natus anno MDLXXXXIV
Picturæ nobilissimæ Arti se se dicavit,

(Præceptore accuratissimo Francisco Pocieco, qui de
Pictura per eleganter scripsit)
Jacet hic, proh dolor!
D. D. Philippi IV. Hispaniarum Regis Augustissimi a
Cubiculo Pictor Primus, a Camera excelsa adjutor
vigilantissimus, in Regio Palatio, & extra ad
Hospitium Cubicularius maximus,
a quo studiorum ergo, missus, ut Romæ,
& aliarum Italiæ Urbium Picturæ tabulas admirandas,
vel quid aliud huius suppelectilis, veluti statuas
marmoreas, æreas conquireret, perscutaret,
ac secum adduceret, nummis largiter sibi traditis:
sic que cum ipse pro tunc etiam
INNOCENTII. X. PONT. MAX. *faciem coloribus mire*
expræsserit, aurea catena pretii supra ordinarii eum
remuneratus est, munismategemmis coelato
cum ipsius Pontif. effigie, insculpta,
ex ipsa ex annulo, appenso;
tandem D. Iacobi stemmate fuit condecoratus,
& post redditum ex fonte rapido galliæ confini Urbe
Matritum versus cum Rege suo Potentissimo,
e Nuptiis Serenissimæ D. Mariæ Theresiæ Bibianæ
de Austria & Borbon, e connubio scilicet cum
Rege Galliarum Christianissimo, D. D. Ludovico XIV.
labore itineris febri præhensus, obiit Mantuæ Carpentanæ
postridie nonas Augusti.

Ætatis LXVI. *anno* MDCLX. *sepultusque est honorifice*
in D. Ioannis Parrochiali Ecclesia, nocte,
septimo Idus mensis sumptu maximo,
immodicisque expensis, sed non immodicis tanto viro;
Hærum concomitatu, in hoc Domini Gasparis
Fuensalida Grafierii Regii amicissimi subterraneos
arcophago: Suoque Magistro, Præclaroque viro
sæculis omnibus venerando, Pictura Collacrimante
hoc breve epidecium Ioannes de Alfaro
Cordubensis mæstus possuit
& Henricus frater Medicus.

* 'Here lies, alas, Don Diego Velázquez de Silva of Seville,
Illustrious painter, born in 1594, he devoted himself to the most
noble art of painting under the very careful instruction of
Francisco Pacheco, who wrote most elegantly on painting. He was
First Painter to the Bedchamber of Philip IV, most August King of
the Two Spains; most punctilious servant to the Bedchamber; and
Chief Chamberlain to the Royal Palace and other residences; in
the conscientious performance of which he was therefore sent with
a large sum of money to Rome and other cities in Italy to look for,
acquire, and bring back with him fine paintings or any other
objects of this kind, such as marble or bronze statues. He also
painted at this time a wonderful head of Pope Innocent X and was
rewarded with a gold chain of extraordinary value and a gold
medal with the Pope's image in relief hanging from it by a ring.
Finally he was decorated with the insignia of Santiago: and after
his return together with his Most Puissant King to the city of
Madrid from Fuenterrabía, on the frontier with France, from the

Even after death Velázquez was pursued by envy, so that when some malevolent people tried to deprive him of his Sovereign's grace through various calumnies falsely imputed, it was necessary for Don Gaspar de Fuensalida, as friend and executor and in his capacity as Keeper of the Records, to answer to such charges in a private audience with His Majesty, assuring him of Velázquez's faithfulness and loyalty and of the rectitude of his conduct in all instances. To this His Majesty replied, 'I well believe all that you tell me about Velázquez, for he was very prudent.' With this, His Majesty attested to the high opinion he had of Velázquez and gave the lie to the spurious shadows with which some had wanted to tarnish the clear splendour of his honourable

wedding of the Most Serene Doña María Teresa Bibiana of Austria and Bourbon – that is, her marriage to the Most Christian King of France, Louis XIV – being taken by a fever due to the fatigue of the journey, he died in Madrid on August 6, 1660, at the age of 66. He was buried with honours in the parish church of San Juan on the night of the seventh of the same month, with the greatest pomp and at enormous expense, but not excessive for such a great man. In the company of heroes, he lies in the vault of Don Gaspar Fuensalida, Royal Secretary, his very great friend. this brief epitaph was composed in honour of his master, illustrious man to be revered by all the ages, by his sorrowful disciple Juan de Alfaro of Córdoba, with the aid of his brother Enrique, physician, while Painting itself wept with them.'

behaviour and the loyalty with which he had always served such all excellent master, from whose generous royal liberality he received so many honours that they can hardly be totalled. But although in the course of his *Life* some of them have been touched upon, they are summarized here, together with others about which it has been possible to obtain notices.

XIII. COMPILATION OF THE HONOURS KING PHILIP IV
CONFERRED ON DON DIEGO VELÁZQUEZ AS WELL
AS THE OFFICES AND EMPLOYMENTS HE HELD
IN THE ROYAL HOUSEHOLD.

In the year 1630, His Majesty granted Don Diego Velázquez lie Silva the stipend of twelve reales per day and a dress allowance of ninety ducats per year.

He granted him a grade of the office of Court Constable, which is set at four thousand ducats.

He granted him a house apart from the dwelling that came with his offices, valued at two hundred ducats per year.

His Majesty granted him a pension of three hundred ducats, which, by Papal dispensation, he enjoyed in the year 1626, and a bonus of five hundred silver ducats in 1637.

He conferred upon him an increased office of Actuary in the Main Weights Office of the Court equal to that of the Criminal Actuaries and set at six thousand ducats.

His Majesty granted him five hundred ducats per year from 1640 onward, to be paid from the daily expenses of the Pantry of the Royal Household.

He granted him sixty ducats per month for his assistance with the Royal Works under the authority of His Excellency the Marquis of Malpica, Superintendent of Works.

He was granted the ample quarters in the Treasury House, which is inside the Palace precincts, while maintaining [the benefit of] the lodgings he enjoyed.

He was honoured with the Habit of the Order of Santiago, with which he was invested.

His Majesty granted him several honours for his son-in-law and for his grandchildren in the Royal Household, as well as posts of great importance and rank in the Audience Chamber.

THE OFFICES AND POSITIONS HE HELD
IN THE ROYAL HOUSEHOLD

His first position was that of Painter to the

Bedchamber, which he held from the year 1623. He took the oath of Usher to the King's Bedchamber – a very honourable position – in the year 1627.

He was promoted to Gentleman of the Wardrobe, and in the year 1642 to Gentleman of the Bedchamber, and in 1643 to Chief Chamberlain of the Palace, an office that he performed to the great satisfaction and pleasure of His Majesty until his death.

From His Majesty's royal hand he received other favours and considerable bonuses, apart from those mentioned, and the benefits of the various positions which he held, all worthy of the greatness of such a King and of the merits of such a punctilious vassal.

Illustrations

All images courtsey of the museums, except pp. 12, 35, 120, & 123 courtsey of Artchive

First published 2006 by
Pallas Athene, 42 Spencer Rise, London NW5 1AP
www.pallasathene.co.uk
© Pallas Athene 2006
Printed in Finland

ISBN 1 84368 031 9/978-1-84368-031-4

Special thanks to Barbara Fyjis-Walker, Philip France and Sebastian Wormell